HAUNTED
WAUSAU

HAUNTED WAUSAU

WAUSAU

THE GHOSTLY HISTORY OF BIG BULL FALLS

SHAWN BLASCHKA, ANJI SPIALEK + SHARON ABITZ

Haunted America

Published by Haunted America
A Division of The History Press
Charleston, SC 29403
www.historypress.net

Cover image: Courtesy of Shawn Blaschka.
All images are from the WPRS Collection unless otherwise noted.

First published 2011
Second printing 2014

Manufactured in the United States

ISBN 978.1.60949.110.9

Library of Congress Cataloging-in-Publication Data
Blaschka, Shawn.
Haunted Wausau : the ghostly history of Big Bull Falls / Shawn Blaschka, Anji Spialek, and
Sharon Williams.
p. cm.
Includes bibliographical references (p.).
ISBN 978-1-60949-110-9
1. Haunted places--Wisconsin--Wausau. 2. Ghosts--Wisconsin--Wausau. I. Spialek, Anji.
II. Williams, Sharon. III. Title.
BF1472.U6B58 2011
133.109775'29--dc23
2011018253

For my patient and loving wife, Jenny, and my sons, Spencer and Andrew. For my dad, who inspired my love of the paranormal, and my mom, who taught me to have patience. Also for my grandpa and grandma, whom I miss each day.
—SB

For my children, Rosemary and Ragnar,
my supportive husband, Terry, and for Pappy.
—AS

For my parents, who thought I wouldn't amount to anything, my husband, who agreed with them, and my children, who call me a nerd.
And especially for my granddaughter, Lotus, who is my connection to the future.
"Be brave, little soldier."
—SA

CONTENTS

Contents

PREFACE

The Wausau Paranormal Research Society (WPRS) is a small group of dedicated individuals who have over thirty-five years of combined paranormal investigation experience. We officially formed in July 2000 and are based in Wausau, Wisconsin. We conduct investigations throughout the state of Wisconsin, as well as some other areas of the United States. Our members are drawn from a number of fields, including academic, criminal justice, social work, business administration, forestry and communications. Our diverse backgrounds allow us to approach paranormal investigations from a variety of perspectives. Our team members are trained in standard ghost investigation methodology and protocols.

We use a variety of the latest equipment to detect and measure electromagnetic/geomagnetic fields, temperature change, ionizing radiation, audio and infrared phenomena in an attempt to obtain scientific evidence of paranormal events. We are TAPS (The Atlantic Paranormal Society) family members representing the state of Wisconsin. Most people are familiar with TAPS as *Ghost Hunters*, the popular paranormal show on the SYFY channel. We are also area representatives of the American Ghost Society. We conduct professional investigations of reported paranormal phenomena, including, but not limited to, UFO sightings, unknown animal sightings, hauntings, poltergeist outbreaks, apparitions and any other "ghostly" events. We make every effort when investigating to look for all reasonable explanations for activity before accepting the possibility that it may be paranormal in nature. Our group's mission is

to collect evidence to aid in understanding paranormal phenomena and events. Most importantly, we strive to provide understanding to our clients so that they may coexist with paranormal activity. We also aim to educate the general public regarding paranormal activity. We never charge for our investigative services, as we feel it would be a breach of our professionalism and integrity. At the request of various organizations or groups, we conduct seminars to aid in educating the general public.

The stories presented in this book are true accounts of activity that have been reported to us, some of which we have personally investigated. Some of the names and locations have been changed or left unlisted to protect our clients' anonymity. In writing this book, we hope that you, the reader, enjoy the following pages and that it educates and opens your mind to the infinite possibilities that may exist.

ACKNOWLEDGEMENTS

We would like to thank the following:

Todd Roll
Edward, Tammy and Kevin Blaschka
Dennis Dalsky
Jane Bubolz and family
Nancy Smith and family
Gillett Historical Society
Marathon County Historical Society and Gary Gisselman
Marathon County Corporation Council
Marathon County Sheriff's Department
Marathon County Public Library
Wisconsin Historical Society
Thomas Gibberd
Tom Pospyhalla
Brad Ludwig
Jim Coscio
Betsy Duginski
Sara Shaw
K.J.
Robin Kurth
Bill Beaudry

Kristen and Justin Lowe
Richard Hendricks
Mike Wanie
Val Nicholson
Alyssa and Josh Geurink
Noah Voss
Kimber Renel
Chad Knight
Tommy Zieglmeier
Robb Shepherd
Dan Miller
The Atlantic Paranormal Society (TAPS)
Candice Shatkins and the Paranormal Investigators of Kenosha

All those who have shared their stories with us over the years.

INTRODUCTION

M any years ago, I read that Wisconsin was one of the most haunted states in the country. With seventy-two counties in the state, at least one haunt has been associated with each county. With more than fifteen known haunts in the downtown Wausau area alone, I would say Marathon County is definitely in the top ten when speaking of hauntings. Why is our area so active? Theories abound in the paranormal community. Could it be that Wisconsin has such a long and rich history that much of this energy has stayed behind in one form or another? Perhaps the high amount of quartzite and granite in the ground around this area is conducive to the storage of spirit energy and past crises. We may never know the true cause of this paranormal activity, but stories will continue to surface. Nonetheless, most of these stories and encounters with the unknown seem to be harmless and sometimes even helpful. In very rare cases, spirit activity is found to be malevolent and house cleansings and religious ceremonies are necessary to eradicate the unwelcome entity.

Many people, including members of the WPRS, have different beliefs when it comes to ghosts. I became interested in the paranormal largely due to my father and his experiences. As a boy, my father would tell me of encounters that he had while working in the old Channel 7 mansion, formerly the Plumer mansion. These ghostly tales piqued my interest in the paranormal, and from that point on, I was hooked. I read anything about the paranormal that I could get my hands on and watched anything on television about the subject. Nowadays there are many ghostly programs to choose from, some more believable than others. The program I most

remember when I was young was *In Search Of*, and the investigative catalyst was *Scooby Doo, Where Are You!* While I realize that this is an odd combination, it was in fact the basis for my lifetime preoccupation with the paranormal.

People always ask me why spirits stay behind after death. One would have to experience death to know, but many theories exist. Maybe they stay due to an earthly attachment to a place or dwelling or due to unfinished business. Perhaps they have a message to give to a loved one or they have died suddenly and unexpectedly and may not even realize that they have passed, staying on in the afterlife in a state of confusion and misunderstanding. Whatever the reason these spirits stay behind, I believe that they are here, and the WPRS is here to try and help these lost or confused souls. As amateur parapsychologists, we look for reasons as to why a haunting is occurring. In the paranormal community, we classify hauntings to determine what may be going on at a site. The four categories by which we classify are: intelligent haunt, residual haunt, poltergeist outbreak and crisis apparition. An intelligent haunt is characterized by spirit activity that is able to communicate with you and has some consciousness of its surroundings. A residual haunt can often be confused with an intelligent haunt, but has one major difference: it has no ability to communicate. Often, residual haunts are much like a film loop playing over and over and doing the same thing each time they are seen. Over time, this type of apparition will fade away. A poltergeist outbreak is thought to be a spirit that uses a living host to manifest itself, usually a female at the age of puberty. Most often they present in a way that is very physical, such as doors opening and closing, cupboard doors slamming, pots, pans and silverware flying across the kitchen and a multitude of electrical anomalies. This type of activity will come on suddenly and cease just as quickly. Finally, a crisis apparition is defined as the visual appearance of a person who is not physically present. It is usually seen only once at the time of death or during great crisis.

When we investigate homes and businesses, we are looking for changes in the known environment. Often you will hear of people stating that they feel a cold breeze or cold spots at haunted locations. Of course, there is always the occasional leaky window or door that could cause this effect, but when that is not the case, it could be due to spirit activity. It is theorized that spirits need energy to manifest. To do this, they pull energy from various sources such as appliances, batteries or the air itself. When they use energy from the air, it is thought to lower the temperature of the air in that particular area, thus creating cold spots. We also look for changes in the electromagnetic field. Unexplained spikes in that field could be

paranormal in nature. A rise in radiation and ions can also indicate that a spirit may be present. Although these ideas are theory, they are widely accepted in the paranormal community. Without question, we look for non-paranormal explanations to any activity first, and 90 percent of the time, we can explain things reasonably. But it is the other 10 percent that keeps us intrigued and looking for answers.

Ghosts have been seen in a wide variety of places all over the world. They have been seen in places new and old, busy and desolate, during the night as well as daytime, and sometimes they look as fleshy and real as any other person. Do they walk among us virtually unnoticed?

Most people might think that one of the last places you would find a ghost would be at a grocery store. However, my experience has been to the contrary. I encountered something about twelve years ago while I was working at County Market in Wausau. A co-worker and I were in a stockroom area when my attention was drawn to a main aisle that led off from the sales floor. Upon looking up from what I was doing, I noticed a white foggy shape forming about twenty-five feet away from me. The hazy shape floated about five to six feet off the floor. As it formed, it became apparent that it had a human shape. The apparition had a head and shoulders, but nothing could be seen below the shoulders. The partial figure had no distinct facial or bodily features and was completely white in color. It was visible for approximately ten to fifteen seconds. During the time that I had been viewing the apparition, I noticed my co-worker apparently staring at what I was seeing. Moments later, the apparition slowly dissolved into thin air. I immediately walked over to the area where I had seen the specter. Upon examination of that area, I found nothing unusual. My co-worker stated that he had seen exactly the same thing I had. I never saw anything "paranormal" in that store again but often wonder, was it a ghost?

Many years later, while speaking at a seminar on the paranormal, I was approached by a gentleman who said that he had once worked for County Market. He stated that a few years prior to my experience a co-worker there had suffered a heart attack and died in that very stockroom. Could this have been the specter that I encountered? Maybe it was a person bleeding through from a parallel dimension or possibly a time traveler looking for the right place to visit the past. Whatever it was, I may never know for sure. What I do know is that whatever I and other people are seeing all over the world must truly exist.

Shawn Blaschka

INVESTIGATIVE HISTORY
AND TOOLS OF THE TRADE

E ver since the infamous Fox sisters drew crowds of visitors to Hydesville, New York, in 1848 with their apparent communications with the dead, people have endeavored to find answers to paranormal occurrences through the use of scientific means. This was the first time that people tried to figure out what was causing a haunting. This was also the birth of spiritualism. Unfortunately, the Fox sisters were found to be fakes, but they set the wheels in motion for thousands of ghost researchers for the past century and a half.

Over the years, several notable paranormal researchers refined this area of study. Some of these influential people developed theories and practices to help capture or detect paranormal activity. One of the early researchers was Sir William Crooks, who worked with mental mediums and developed a scientific way of studying paranormal activity.

Another researcher was Harry Price, who in the paranormal community is known as the "Father of Modern Parapsychology." He began his studies largely as a disbeliever in the supernatural. Over the years, his research led him to the conclusion that there were more questions than answers. Price also developed the first standard ghost hunters' kit. It was composed of a compass (to detect changes in the magnetic field), soft felt shoes (for walking quietly), a measuring tape (to check for movement of items), screw eyes, lead seals, tape, string and bells (for a primitive motion detector), a camera, film, flashbulbs (to capture any paranormal activity), a notebook and a medical kit in case of injury. Lastly, what would be somewhat lethal by today's standards,

the kit included a bowl of mercury. This was used to detect tremors at a haunted location.

Another significant personality in paranormal research was Harry Houdini. He was most recognized for his amazing escapes and magician abilities, but what most people do not know is that Houdini was largely involved in spiritualism and the paranormal. He knew many of the tricks used during séances by charlatans, and he set out to debunk trickery and deception. This is similar to what paranormal researchers do today.

Clearly, many things have changed since the early days of ghost hunting, yet some are still very similar. The answers we seek are still the same, and we keep looking to find an answer to what millions have experienced through the ages.

Today there are many standard tools that paranormal researchers use. All of these tools are based in theory. No living person knows all the answers, so researchers experiment with various devices to try to capture evidence of ghostly activity. One of the most important tools any researcher can have is the human brain. The highest regard and integrity goes to researchers who can use their observations and ability to process information logically and reasonably without jumping to any hasty non-supported conclusions. The main goal of any good paranormal researcher is to try to help people understand what may be going on in their homes or businesses. Another goal is to provide a level of comfort so that the client can live harmoniously with whatever may be present. At no time should a paranormal research group charge money for investigative services. Beware of those that do. It is this writer's opinion that anyone requiring monetary benefit for this service should be scrutinized, as their integrity is questionable.

Our hope is that with the following glossary and previous information, the reader can gain a basic understanding of the terminology and equipment used in paranormal investigating. Most of this equipment is used widely by paranormal researchers throughout the world, with some exceptions for individual preferences.

BASIC FIRST AID MEDICAL KIT: Most paranormal researchers carry a basic medical kit in case of any injury that may occur during an investigation.
BATTERIES: Researchers carry all varieties of batteries needed for their equipment. Sometimes during investigations batteries quickly go dead (i.e., spirits draw energy from any source available to manifest), so replacements must be readily available.

CASSETTE AND DIGITAL AUDIO RECORDERS WITH LOW IMPEDANCE MICROPHONE: These types of recording devices are used to capture electronic voice phenomena (EVP) while at possible haunted locations. EVP occurs when a sound or voice is heard on audio that was not heard by investigators during the recording session. This equipment is also used to record interviews with clientele. The advantage of a cassette recorder is that a tape is available as evidence that can later be analyzed to prove or disprove the authenticity of the recording. The advantage of a digital recorder is that audio can be easily transferred to a computer sound file. The low impedance microphone allows us to record with less background noises, thus providing more clarity when analyzing the audio.

CCTV (CLOSED CIRCUIT TELEVISION) MONITORS: This allows investigators to visually monitor areas in real time during an investigation through the use of a digital night shot or DVR system, while at the same time recording for later review.

CONVENTIONAL CAMERAS: Excellent way to record the environment photographically. This type of camera is less often used by paranormal investigators due to the cost of film and development. Another disadvantage is that it does not provide instant results. However, the absolute advantage with this type of camera is that it produces a negative to help in determining whether various film anomalies are paranormal in nature, leaving the researcher with evidence that can be analyzed and preserved.

CONVENTIONAL THERMAL PROBE: A conventional probe is used to measure air temperature. In theory, when a spirit manifests it needs energy to do so. It will often draw energy from any source available. One of those sources is in the form of heat energy in the air. When it removes that heat energy from the air, the temperature will drop dramatically, and cold spots can result.

DIGITAL CAMERAS: A very economical way to record the environment with instant results available to review. Paranormal researchers use this type of camera most frequently. The drawback in using a digital camera is the fact that it does not produce a negative as evidence. Evidential proof makes a case much more credible, and digital cameras produce photos that can be easily altered with computer programs, lending less credibility.

DIGITAL NIGHT SHOT HANDHELD CAMERAS: Used to record and monitor any evidence of paranormal activity. This type of camera can be used in areas where there is complete darkness. This is also a very useful tool as all other electrical sources can be eliminated while filming and the system is mobile. A common theory is that spirits manifest in spectrums of light that are not visible to the naked eye. One of those possible spectrums is the infrared

spectrum. The camera operates through the use of an infrared beam that illuminates the background, thus theoretically making paranormal manifestation visible.

DIGITAL VIDEO RECORDER (DVR) SYSTEM: This allows researchers to monitor several different areas at the same time while capturing video evidence digitally. This is a very useful tool, as all other electrical sources can be eliminated while filming. DVR infrared cameras can record in complete darkness up to several hundred feet away with crystal clarity.

EMF (ELECTROMAGNETIC FIELD) METERS, ANALOG AND DIGITAL: These meters are designed to detect changes in the electromagnetic (AC) field. In theory, when spirits manifest they draw on energy sources from the environment around them. This gathering of energy creates a magnetic field that is much higher and quite different than that of its surroundings. In theory, if an investigator with one of these instruments passes through an area that is occupied by a spirit entity, the meter will show a spike or a rise in the electromagnetic field. Usually it is hard to re-create this "spike" or "hot spot," as they are commonly known, because the field is theoretically in motion. Science states that man-made magnetic fields do not move.

EMF (ELECTROMAGNETIC FIELD) NATURAL METER: These meters are designed to detect changes in the natural electromagnetic field. This instrument is very similar to the EMF meter; the principle, however, is a bit different. This meter will detect changes in natural fields such as those that encompass living beings. It can also detect electromagnetic fields that are created naturally, like lightning or geomagnetic storms. This type of meter will ignore AC fields.

EVIDENCE BAGS, MASKING TAPE, CHALK AND TAPE MEASURE: Evidence bags are used to collect evidence at the scene. The masking tape, chalk and tape measure are used when a control item is placed in an area that is being monitored with other equipment. The control item would be marked with masking tape or chalk and monitored for movement. Any movement would be documented by taking a measurement and recording it with other supporting equipment.

EXTENSION CORDS, COAXIAL CABLE, DIGITAL CABLE AND RF MODULATORS: These items are needed to operate video equipment and for use with a DVR system or closed circuit televisions.

FLASHLIGHTS IN ASSORTED VARIETIES: All researchers use a variety of different illuminating instruments. Many use lights that are shaded so that they do not interfere with your vision while in total darkness and lights that attach hands-free so that other equipment can be carried.

GEIGER COUNTERS: These devices are used to check for any rise in gamma radiation. In theory, a spirit presence raises the amount of ion particles in the air; radiation attaches to those ions and therefore raises the radiation levels. Intermittent rises in radiation levels are thought to be paranormal in nature.

INFRARED THERMAL PROBES: These devices measure the surface temperature of objects from a distance through the use of an infrared beam. This device does not give you an air temperature reading but, rather, the surface temperature of what the beam hits.

MOTION DETECTORS: These devices are often used to make sure an area that is being monitored is not entered by anyone, thus avoiding any contamination to the site being surveyed. It also helps determine if any unseen motion is present in an area during a vigil.

TWO-WAY HANDHELD RADIOS: Most researchers use these to communicate with each other during investigations. They are especially helpful in large buildings, where more than one building is involved or in large outside areas.

Hopefully this chapter has given you, the reader, a basic knowledge of where paranormal research began and where the field is going. It should also provide you with some investigative background when reading the subsequent stories. We hope you enjoy what *Haunted Wausau: The Ghostly History of Big Bull Falls* has to offer.

BIG BULL FALLS

Wausau, Wisconsin, is a city situated in the middle of the state on the banks of the Wisconsin River and known as the "Gateway to the Northwoods." Thought to originally be a campground for Chippewa Indians, the area held much allure for the lumber barons of an earlier era. After the 1836 federal Indian treaties opened the land to pioneers, the first recorded non-native settler, George Stevens, came to the area from Pennsylvania sometime during 1838 to survey the river and land for mill sites. George Stevens traveled by land with three ox teams, minimal supplies and rudimentary tools to Plover, Wisconsin, and from there he traveled up the Wisconsin River northward in canoes made from hand-hewed logs.

Nearing the area of the current city, George Stevens undoubtedly heard the roar of the river's great rapids long before he arrived on site and, as others have since, marveled at the "terrible roaring sound" made by the rocky rapids. That roaring sound was likened to the guttural roar of a bull, hence the first name for the area—Big Bull Falls.

Shelter was of major importance early on, and Stevens built the first shanty in Big Bull Falls out of logs with clay-filled chinking. The first log mill in the area, Stevens Mill, was built in 1840 and named after its owner. The logging era had begun. More mills and loggers soon followed, and the industry was in full swing by the early 1840s. Being densely grown with huge pines and not yet appropriate for farming, the area became known as "the pinery," and loggers and water rafters stampeded into town looking for work

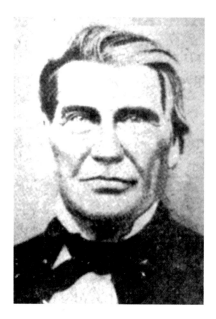

George Stevens. *Courtesy of the Marathon County Historical Society.*

and entertainment. By 1845, the first tavern, the Blue Eagle, was built near the east bank of the slough, west of present-day Jackson Street.

One must remember that this was still wilderness, raw and untamed, and when food provisions ran low it was often reported that men subsisted on pigeons and huckleberries. Obviously, this was during the warmer months, when vegetation and wildlife were abundant. But during a particularly harsh 1843 winter, lumbermen's lives were in peril, as two feet of snow fell over as many days and supplies were extremely late in getting to the camps. Luckily, none of the loggers starved to death. The same cannot be said for the local Indians. Whether this is a true story will never be known, but an Indian chief named Mayig supposedly killed his wife during this horrible winter so that he and his children could "subsist on her remains."

The men working in the lumber mills were paid approximately sixteen dollars a month and received their wages once a year each spring in the form of lumber. Between the millworkers, lumberjacks and rivermen, the town would become a hotbed of testosterone-fueled activities when they were all in town on any given day. Fighting was a common activity in the pioneer days, and each river town had a man who was considered the best at fighting. These fights usually ended amicably, with the loser and the victor shaking hands, but on occasion, men were severely injured or killed during a fight. In the summertime, it was almost a daily occurrence to see groups of men rushing through the town's dirt streets to get to the next big fight, with whiskey and bets flowing freely.

In the early years of Big Bull Falls, when the lumber mills were in full production and the buildings were made of wood, entire blocks were wiped out by fires because once they started there was little to stop them. Before an official fire department was organized, fires were fought by whoever was available by forming a fire brigade and sending water up from the river. Looking back through historical reports, it appears that when the fires

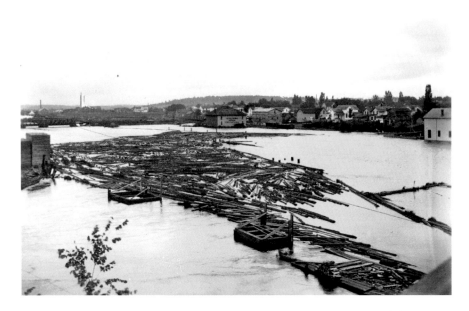

Logging scene on the Wisconsin River. *Courtesy of the Marathon County Historical Society.*

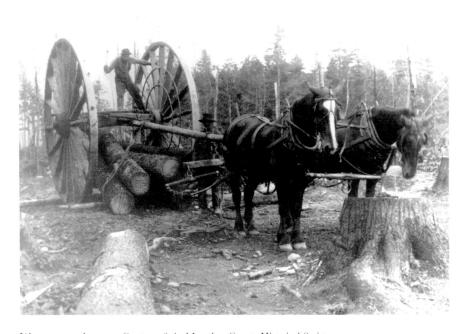

Wausau area loggers. *Courtesy of the Marathon County Historical Society.*

Pine Grove Cemetery memorial for those pioneers reinterred after the 1860 flood.

weren't burning, the town was being inundated with floodwaters. The living was hard, and many a business fell into ruin by flood or fire, only to be rebuilt by determined settlers.

With even a small population, a town must decide where to bury its dead, and this became a risky proposition in Big Bull Falls. Several small burial grounds were located in or near the town, and in the 1850s the area was very wet due to small creeks running through it. Fearing the worst, citizens were advised to move the bodies of their loved ones to a new cemetery prepared farther inland. Unfortunately, a severe storm in 1860 drenched the town before all of the bodies were reinterred. The remaining caskets and their decaying contents from a cemetery located near the river were washed away down the river. No bodies were recovered after the washout, and what few unidentifiable remains were found were reburied.

The undeniable forefather of Wausau is Walter McIndoe, who originally came to Big Bull Falls to collect a $500 debt in 1845. Transfixed by the natural beauty of the pinery, he returned in 1846 with the express purpose of making the area his permanent home. Upon arrival, McIndoe started

a mercantile business, built a home and then brought his wife to town from St. Louis. He and Charles Shuter later purchased Stevens Mill from its owner in 1850, and the mill became known as McIndoe Mill. Meanwhile, George Stevens sold all of his possessions and moved out of Wausau searching for quicker sources of profit, and McIndoe dedicated himself to making Big Bull Falls an accessible and civilized town that was in touch with the outside world.

McIndoe was a major force behind the organization of Big Bull Falls into a town on October 10, 1849, and he spent the remainder of his life positioning the area for the city

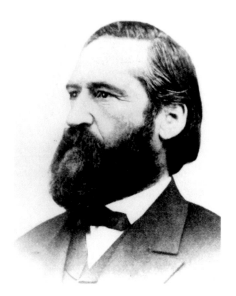

Walter McIndoe. *Courtesy of the Marathon County Historical Society.*

that it has become. In the spring of 1850, McIndoe named the surrounding county "Marathon" after a city in Greece, and in 1852, McIndoe surveyed the town of Big Bull Falls and plotted it out for lots and streets. When Big Bull Falls was named the county seat, McIndoe decided that the town needed a new name and chose the name Wausau, which in the Chippewa language means "faraway place." This may be a misinterpretation, for in another Indian language the word Wausau is said to mean a "noise like thunder," which would be very appropriate given the noise of the river rapids. Notwithstanding, Wausau was organized as a village in 1861.

Big Bull Falls had been growing by leaps and bounds since its first inhabitant arrived. In 1844, the population of Big Bull Falls was 44 and by 1850 it had grown to 477, although this number included the village and several small surrounding settlements. After the first railroad came to Wausau in 1874, the village was inundated with new residents, and by 1875, the population was 2,820. By 1880, the population had soared to 4,275.

By the late 1860s, the lumberjacks and rivermen had started to move farther north in search of exploitable timber, for the local timber sources had been all but depleted. As the brawny lumbermen left the area, those businesses that catered to their interests, especially taverns, decreased in number, as did the rowdy fistfights. With the absence of the lumbermen and

the inundation of new citizens arriving by train searching for city amenities and refinement, Wausau was ripe for the influx of all things citified. Wausau was incorporated as a city on April 2, 1872, and its first mayor, August Kickbusch, was elected for a one-year term. Many city mayors have been elected since that time, and Wausau has continued its upward mobility to become a main center for commerce, technology, education, the arts and outdoor recreation.

Though Wausau was now a proper city, its days of drunken violence had not ended. In the summer of 1880, two local dentists were involved in a business struggle that ended in the death of one and the insanity and incarceration of the other. Dr. Edwin Hogle was a twenty-six-year-old dentist new to Wausau and opening a dental office in July; Dr. James Bennett had been practicing dentistry in Wausau for six years, usually without competition. Dr. Bennett had a dental monopoly in the city, and he liked it that way. The fact that the young upstart dentist had encroached on his lucrative territory enraged Dr. Bennett, and he went on an extended drinking binge, traveling from saloon to saloon and vowing "that he would make things hot" for the new dentist.

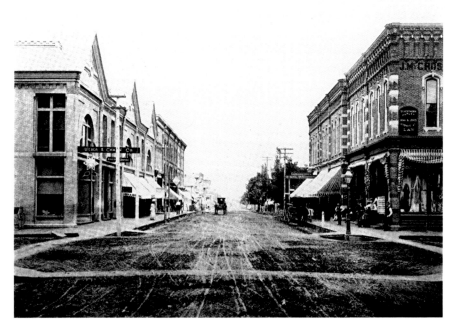

Third and Scott Streets in downtown Wausau, circa 1890. The McCrossen building, the first building on the right, is the site of the notorious 1880 murder of Dr. Hogle. *Courtesy of the Marathon County Historical Society.*

The new office opened on August 9, and Dr. Bennett, drunk and agitated, was making threats against the new dentist to anyone who would listen. The next day, Dr. Bennett confronted Dr. Hogle, and while the confrontation seemed amicable, it is unknown for sure what was said between the two men. Shortly thereafter, Dr. Bennett went into several different businesses on Third Street asking to borrow a shotgun. When questioned about the request, he told one person he was taking a trip up the river and another that he planned to shoot a dentist. Walking into the new dentist's office at about 5:30 p.m. with a borrowed double-barrel shotgun, Dr. Bennett yelled, "God damn you, Hogle!" and shot, blowing open Dr. Hogle's stomach and side. Dr. Hogle gasped, "My God!" as he fell to the floor, dying within seconds.

While we do take our dental care seriously here in Wausau, no recent dentists have been harmed. And while the big river's power has been harnessed and hushed, to some extent, it is still possible to imagine George Stevens's first encounter with the "terrible roaring sound" of Big Bull Falls when the floodgates are opened on the annual whitewater kayaking season in Wausau. As you stand riverside watching the contestants hitting the slaloms, take a few moments to gaze off into the distance and you may see the ghosts of lumbermen pitching quoits or raftsmen moving lumber down the Wisconsin River. You may even catch a fleeting glimpse of a French Canadian man named Champigne, the first raftsman to die when moving lumber here on the river in 1841.

HAUNTED ESTABLISHMENTS

WAITING IN THE WINGS

Theaters have graced the Wausau community for as long as people have lived here. It goes almost without saying that every city has a theater and that every theater has a haunt. One of Wausau's earliest theaters was the Wood's Opera House, which was built in 1883 and was located on the corner of Scott and Third Streets. The theater was known as the pride of Wausau in its day. The building was large and encompassed almost the entire block. This theater, however, did not survive long. Fire broke out in a nearby saloon and spread quickly to the theater. In what sounds comical by today's standards, the fire department at the time was sent to the wrong address. Once they found the right address, the building was already engulfed in flames. The fire pump froze up, and it took too long to get water from the nearby river. However, the firefighters did save the whiskey from the saloon and all got drunk while they watched the entire 500 block of Third Street burn to the ground. Unfortunately, no one on the block had insurance, and it dealt a devastating blow to the community.

The second theater in Wausau was built in 1892 and was named the Alexander Opera House. This theater was used until 1899, when the Grand Opera House was built on the site of the present Grand Theater. In 1927, the Grand Opera House was razed and replaced with the Grand Theater. The Grand Theater opened on Thanksgiving Day 1927 featuring

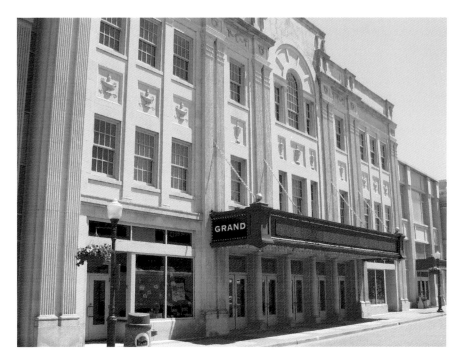

The Historic Grand Theater in downtown Wausau.

five screenings of Cecil B. DeMille's *Dress Parade* with Lawrence Bernhardt at the Kilgen Wonder Organ. The Grand Theater is located at 415 North Fourth Street in downtown Wausau and has been a cornerstone of the Wausau community for almost a century now. Originally a vaudeville/silent movie house, it has changed functions over the years, showing motion pictures from 1932 to 1985. The theater has also been host to numerous plays, movies, musical performances and, of course, several ghosts. In 1986, 2001 and 2003 it went through renovations. During renovations, power mysteriously shut off in the basement. Electricians tested the wire and found it electrified, but when they tried to power equipment the line was dead, only to become electrified again.

It is theorized that sudden death can leave a trace of one's personality behind. In some cases, the spirit of that person may become trapped within the walls in which they passed away. Four deaths have taken place in the Grand Theater over the years, the first being during the theater's construction. A workman laying bricks for the back wall of the theater fell from a sixty-foot-high scaffold to his death. Another man was electrocuted on a circuit panel near the stage, and yet another man was killed when a

baton fell from above the stage, striking him in the head and killing him instantly. Lastly, a patron in the audience died of a massive heart attack during a performance.

The earliest report of ghostly activity in the Grand Theater was from 1950. An usher at the time stated that he had just come up from the usher's room after changing clothes. The doors to the theater were locked, as he had previously done an entire sweep of the theater. He started up aisle number three when something caught his eye in the boxes on the north side of the balcony. The usher stated that it looked like a figure moving slowly to the east. He called out "hi" and waved, thinking it was the night cleaning man. The figure did not respond, and the usher once again yelled out to it. The figure looked down toward him, but again, no response. So the usher continued down the aisle and briefly looked back, but the figure was no longer there. He then went to the lobby, turned out the lights and went outside to lock up the building. Once the usher finished locking the door, he saw the night cleaning man running up the sidewalk toward him. He stated that he was sorry he was late. Stunned, and thinking an intruder was still in the theater, the usher called the police. When they arrived, the theater was searched but no one was found, nor had any of the emergency exits been opened. So who was the man the usher saw on that night long ago?

Another report from the 1950s was of movie canisters being moved from the upstairs projection room to the lobby with no explanation. Sometimes these canisters were found in the ticket booth as well. Over the years, other manifestations have been reported: phantom footsteps, apparitions, electrical malfunctions, disembodied voices and whispers, cold spots, unexplained puddles of water and shadows, as well as feeling a strong presence. Several staff members reported voices coming from a room behind the balcony. A search revealed no one in the building. Stagehands have reported the sound of footsteps heard walking across the empty stage. When investigated, the source of the footsteps could not be located. Also, the lights have been found turned on in the spotlight rooms with no explanation as to who turned them on.

Once, a theater worker noticed movement in the balcony area. When he looked up, he witnessed an apparition of a man appear along the back wall behind the seating. The apparition was seen in the exact spot where the projection room door had once been. When the worker looked away and back again, the specter had vanished.

The apparition of a man has been seen in the lighting rack above the stage by numerous people. This same apparition has been seen walking down

Possible energy orb captured on the railing of the Grand Theater balcony where apparitions have been seen. *Courtesy of Todd Roll.*

the spiral staircase from the lighting rack and crossing the stage directly in front of several witnesses. Many have identified the apparition as one of the former stage managers who has since passed away.

Over the past several years, performance companies have graced the stage of the Grand, but to their dismay, they have not been alone. A ghostly visitor has been seen by several performers during closed rehearsals. Most often, these performance companies would make complaints to the Grand's staff about an elderly man watching them from the back stage during a closed rehearsal. When this happens, the staff informs them that the visitor may be a former stage manager who has been dead for many years.

The WPRS investigated the Grand Theater in July and November 2001 and again in March and September 2002. In 2001, the WPRS took photos of the balcony where numerous apparitions have been seen over the years and an anomalous ball of light was captured. No one saw the ball of light while taking the photograph. It is located in the center of the photo and appears to be wrapped around the railing.

In November 2001, we recorded some audio in one of the spotlight rooms. After playing back the tape, a voice can be heard saying, "Don't go back over here." The voice was not heard during the recording. Prior to that EVP, the team experienced a change in temperature, whispering sounds and unexplainable interference with our two-way radios.

The WPRS returned to the Grand in March 2002 to collect further evidence of paranormal activity in the spotlight room. During the investigation, EMF meters detected electromagnetic anomalies in the

room. A video recorder was placed in the room along with an EMF meter equipped with an audio device to alert us to potential paranormal activity. The room was monitored from a remote location. During the recording, the meter detected a change in the magnetic field. At the same time, a ball of light moved across our video screen.

We highly recommend that you attend a performance at the Grand Theater when you are in Wausau and hope you find the theater as interesting as we have. Maybe you will even get a bit more entertainment than you bargained for.

THE HEART OF OLD WAUSAU

The Wausau Center Mall, located in downtown Wausau, first opened its doors to the public on August 3, 1983. It encompasses eight blocks of what was originally the heart and soul of downtown Wausau. Prior to the Wausau Center Mall, the area was home to the Northern Hotel, East Side Fire Station, Herman Achterberg's Blacksmith Shop, Wausau's first courthouse, the *Wausau Pilot* newspaper office, Eagles Dance Hall, Kickbusch General Store and numerous livery stables, boardinghouses, grocers and saloons.

Unfortunately, as the years wore on, many of these buildings began to deteriorate. In the 1970s, downtown Wausau was in a state of blight, and residents and city officials realized that something must be done to clean up the area. In 1979, the citizens of Wausau approved a referendum to construct a shopping center downtown. The 500,000-square-foot mall was designed by Jacobs, Visconsi & Jacobs to accommodate three large department stores, as well as sixty-five smaller shops.

Demolition began on Tuesday, August 26, 1980, with the razing of Wausau's old bus depot. In celebration, the city threw a block party for onlookers, featuring free beer and soda and live music. Over the course of the large-scale demolition, approximately sixty-seven buildings were razed, most dating back to the 1850s through 1920s.

Nearly three years after the demolition of the bus depot, the citizens of Wausau gathered to celebrate the grand opening of the Wausau Center Mall. The festivities continued from August 3 until August 7, 1983, and included parades, clowns, dances, ethnic food stands, hayrides, free movies at the Grand Theater and a fireworks display. Revelers could also help

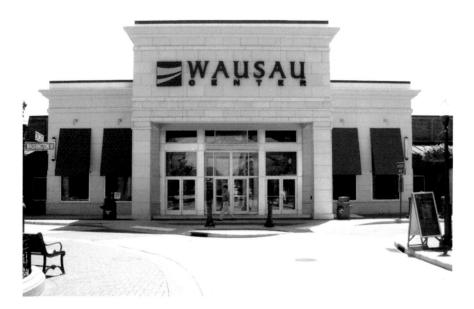

Wausau Center Mall.

themselves to slices of a free one-hundred-foot-long cheese sandwich. It is estimated that 120,000 people attended the five-day event.

Although the streets of old Wausau have been long forgotten within the mall, many believe that the ghosts of the city's past still linger there. Night employees have witnessed the apparition of a man at the end of the mall opposite from where they stand. He is well dressed in a suit, tie and hat and appears to be translucent. The man lifts an arm in greeting, walks down a mall corridor and seemingly disappears. When employees investigate, no one can be found. The mysterious man is sometimes seen with a ghostly black dog.

An employee encountered an entity one evening while walking toward the mall's center court. A black figure stepped out from behind a lamppost and then ducked behind a bench. When the employee got closer to the bench, the figure had vanished.

A night security officer, while walking through Wausau Center Mall one evening, saw a woman standing in the middle of one of the mall's clothing stores. While the woman was standing behind a clothing rack and could only be seen from the neck up, the officer got a clear enough look at her to notice that she was wearing her hair in an off-the-neck style. The apparition

quickly disappeared, and although the security officer spent several minutes surveying the store, he witnessed nothing else out of the ordinary.

Perhaps even more alarming is the phantom that has been seen near the mall's center court. It is a large, vaporous mist that seems to rise from the ground. It moves as if it were a cloud of insects, shifting and rippling until it reaches its full height of twenty feet, at which point it slowly dissipates.

The food court of Wausau Center Mall has seen its fair share of ghostly activity as well, particularly the area that used to house McDonalds. Evening employees there reported hearing chairs moving around well after the restaurant had closed for the night. Ketchup packets would fly from their proper containers and be thrown to the floor by unseen hands. Soda cups would pop out of their dispensers, one after another, until the dispensers were empty.

Until the early 1990s, Wausau Center Mall was thought to be home to a lively spirit nicknamed "the Pincher." According to legend, the Pincher was a mall investor who had dealings with the mob. He was murdered during mall construction and buried under the floor near JC Penney. Throughout the 1980s, the Pincher made himself known by pinching the bottoms of women as they walked in front of JC Penney. It is said that most of his victims would turn and slap the nearest man unfortunate enough to be walking behind them.

While we may never know the identity of the dapper man and his dog or where the Pincher is really buried, it is certain that the Wausau Center Mall is an area steeped in history. The next time you find yourself shopping there, keep an eye on your fellow shoppers, and be sure not to walk too closely behind them.

Beauty Discarded

Located at 309 McClellan Street in Wausau, Wisconsin, the Wausau Club is a beauty to behold. Four tall white columns grace the front entrance of the Classical Revival building, giving it the air of a southern plantation of imposing wealth. This beauty has wined and dined several famous visitors: Reggie White, former Green Bay Packer; Captain Kangaroo, who needs no introduction; and Hillary Rodham Clinton, current U.S. secretary of state, just to name a few. Seeing the building lit up at night, one can almost see the glint of silver flatware and hear the tinkling of fine china and crystal against the musical backdrop of a melodious orchestra.

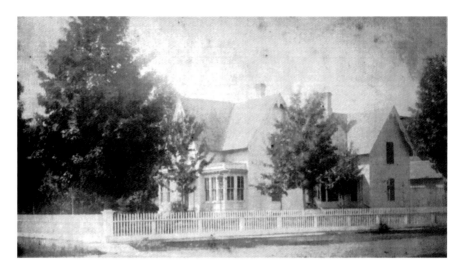

The Rufus P. Manson home, on the site of the Wausau Club. *Courtesy of the Marathon County Historical Society.*

Prior to becoming the site of the Wausau Club, the property was the location of the Rufas P. Manson house. Built in 1865, the Manson home was a large Gothic Revival–style building used to house the couple and their twelve children. The home was so large and functional that when sold in 1900 it was split into two separate buildings. The home's sections, thus torn asunder, were moved to 509 and 515 Adams Street in Wausau, where they remain to this day. A gothic romantic might sit and ponder the separation of these twins and wonder what secret longings hide within each.

Once the Manson home was sold and dismantled, the original Classical Revival building was designed and erected to serve as the clubhouse for the newly formed social club, which catered to the elite logging and businessmen of the era. The building has been renovated and had several additions, but the Wausau Club remains bound to its original location all these years later. A 1912 expansion added a kitchen and converted a billiard room into a café, and in 1922 a sixteen-room dormitory was added to the west side of the building to house visiting professionals and club members needing temporary lodging. Throughout the years, the Wausau Club has delighted and entertained its club members, their families and friends with teas, birthday and holiday parties, formal balls and holiday dinners. No doubt about it, the private club was the playground for Wausau's rich and famous.

For lack of sustainable membership, the classical beauty has been locked behind a chain-link fence since its closure in 2004. Year after year it sits empty and desolate, longing for the admiring attentions of passersby and beaus long past—a beauty used and abandoned, much like the infamous Martha. Martha's story could serve as a metaphor for the Wausau Club, for both were discarded when their usefulness as a plaything or temporary distraction had ended.

Martha is reported to be a grieving ghost who endlessly wanders the halls of the Wausau Club and peers out darkened windows, waiting for the return of her discourteous lover. Alleged to have been a previous Wausau Club employee who was wooed and then jilted by a wealthy man when she became pregnant, Martha is said to have hanged herself in the north room of the dormitory section. Former employees have reported hearing the elevator flitting between floors but never stopping to open its door. They later heard footsteps on the staircase, but when they searched for the interloper, no one was there.

Other employees have stated that they have felt a presence while alone in various rooms or could feel that someone, or something, was staring at them. On different occasions, employees have taken their necessary precautions to close up the building at the end of the workday—turned off kitchen equipment, turned off lights and locked the doors—only to exit the building, turn and see lights blazing inside, supposedly turned on by an unseen force or entity. The north room of the dormitory, known as Martha's room, was one in which lights have been noted burning after being turned off for the night. And passersby have been known to quickly leave the area after looking into the darkened north room and seeing a face peering out of the window at them. Could this be Martha, waiting for the return of her unborn child's father?

Martha may not be the only ghost that haunts the Wausau Club, for an apparition has been seen on the grand staircase looking over the railing as if waiting for someone. This writer, while attending one of the last wedding receptions held at the club before it was closed, was walking toward a smaller rear staircase in search of the lavatory. Looking up the staircase, I saw a slender, red-haired woman who was beautifully coifed and dressed in a flowing, Victorian-style gown. Enthralled, I watched as she started to descend the staircase, head held high and back arched into perfect posture, before I realized that she may not be of flesh and blood. I quickly looked around the area to see if anyone else had seen the woman, but no one was nearby. When my gaze returned to the stairway, the mysterious Victorian lady had vanished.

There have also been numerous reports over the years of footsteps being heard in the second-floor ballroom, but when the room is investigated, it is found to be empty. Could this be a residual haunting from the era of Prohibition and flappers? Interestingly, the secrets of the Wausau Club are being revealed even to this day. During a 1997 excavation in the basement of the current Shepherd & Schaller Sporting Goods store, an underground tunnel was found that ran between the store and the Wausau Club. During Prohibition, the store was the location of the *Wausau Pilot* newspaper office, and evidence suggests that the tunnel may have been used to hide outlawed alcohol in case of a police raid. Perhaps the tunnel also served as a hidden transport route for female entertainment in the early days of the club when it was strictly a gentlemen's club to be used for social intercourse. One never knows.

The WPRS completed an investigation of the Wausau Club in April 2005, and several items of interest were noted. Two EVPs were found upon reviewing the investigation's recordings: a voice that did not belong to any of the investigators present was heard to say, "Keep [inaudible] Here...Turn," and a second faint male voice was heard to say, "What!?" Perhaps long-dead bartenders mistakenly took the investigators for a police raid and were shouting directions to hide the booze. Finally, two photographs taken in the bar areas of the club were found to contain glowing orbs in specific locations where an investigator felt a strong presence and actually saw a dark figure standing in an archway.

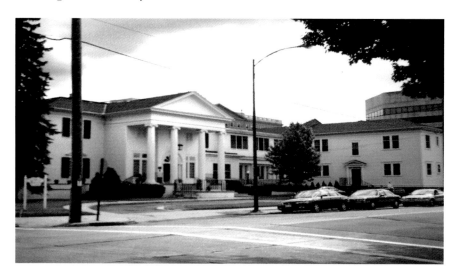

The Wausau Club, circa 2005.

The Wausau Club was listed as a National Historic Landmark in 1989, and the current owner had been making valiant efforts to restore and reopen the building for use, but a dearth of investment money has put an end to this lofty project. The centennial-plus beauty sits as a testament to old-fashioned wealth and conspicuous consumption while it awaits a new owner. The Wausau Club and Martha share much in common, as well they should, for they are worthy of both the lust and repulsion that they engender in onlookers. And, sadly, they are both discarded beauties. So when you visit the Wausau Club, and we know you will, remember that even if you fail to see Martha peering at you from her dormitory window, the club itself is peering at you through its chain-linked captivity.

BURNING THE MIDNIGHT OIL

Dedicated employees are difficult to find, and the JC Penney Company hit the jackpot when it hired "Eddie." The custodian is still hard at work at Shepherd & Schaller Sporting Goods, although he died after a heart attack decades ago.

The building, at 324 Scott Street in Wausau, was built in 1880 and first housed Gustav Kishel General Merchandise. The shop did not last long, however, and in 1888 it became a boardinghouse known as the Germania House.

In 1893 it became home to the *Pilot Review*, one of Wausau's first newspapers. The *Pilot Review* changed its name to the *Wausau Pilot* in 1901 and remained in the building until 1941. It was during its tenure as the *Wausau Pilot* that a tunnel was built in the basement of the Shepherd & Schaller building linking it to the Wausau Club. While the tunnel has been bricked over, you can still see the archway where it was located.

In 1917, the JC Penney Company opened up the first store east of the Mississippi River in Wausau, choosing the first floor of 324 Scott Street for its home. The *Wausau Pilot* office was located upstairs at that time. JC Penney moved out of the building in 1956, and for a few years it housed the Marathon County Agriculture Stabilization and Conservation office.

Shepherd & Schaller Sporting Goods moved into the site in 1961 and shared the building with Sherwin Williams Paint until 1980, at which point Shepherd & Schaller bought the adjoining building and expanded to occupy the entire place.

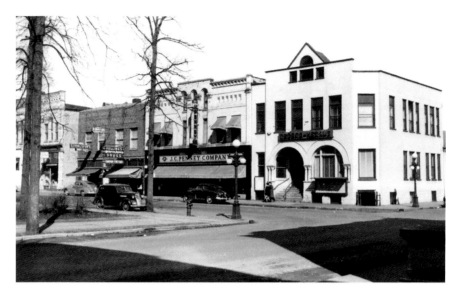

The original JC Penney building as it looked when "Eddie" was employed there. *Courtesy of the Marathon County Historical Society.*

Employees of Shepherd & Schaller have been having paranormal experiences since the very beginning. Legend has it that Eddie, JC Penney's hardworking custodian, is still there, making sure that current employees are doing their best work. Eddie seems to be a friendly soul, watching over the store and making his presence known when workers are goofing off. He may set off the door alarm, turn lights on or off or make things disappear, only to show up later in unusual places. Witnesses have seen hats fly off the store shelves, perhaps moved by Eddie's unseen hands.

The attic of Shepherd & Schaller is referred to as Eddie's room, as his presence can often be felt there. Employees do not like to go to the attic alone, but sometimes it can't be helped. On one such occasion, a clerk was ascending the staircase into Eddie's room when two chunks of plaster flew off the wall, hitting her in the face. She witnessed the plaster come loose and reported that it didn't fall but instead moved horizontally toward her. This is the only account of violent activity that has been reported in the building over the years.

The basement, affectionately referred to by employees as the "dungeon," has also had its fair share of ghostly activity. In the 1970s, two employees were working there, removing ski boots from their boxes and lining them up on shelves for the annual Dungeon Sale. Both young men heard a male

voice in the room with them, though no one else was present. As they turned to leave the basement, they witnessed the boxes that they had just unpacked being thrown around the room by supernatural hands.

Also in the Shepherd & Schaller dungeon, a clerk left a freshly opened can of soda sitting on a shelf while he ran upstairs for an errand. When he returned, the can sat exactly where he had left it, but half of the soda had been dumped out onto the floor. No one else had been in the basement that evening.

In that same room of the basement, on another occasion, a worker was unpacking inventory. When he finished with a box, he would throw it into a nearby unused stairwell. When his work was completed, he went into the stairwell to organize the empty boxes and found them already neatly stacked. Eddie, with boundless dedication, was there to lend a helping hand that day.

The WPRS has investigated twice at Shepherd & Schaller. On October 31, 2002, we were contacted by a local television station, WSAW Channel 7, about the activity that has been experienced in the store. A short investigation was performed and filmed by Channel 7 for a Halloween newscast. During the investigation, an unusual EMF reading was found

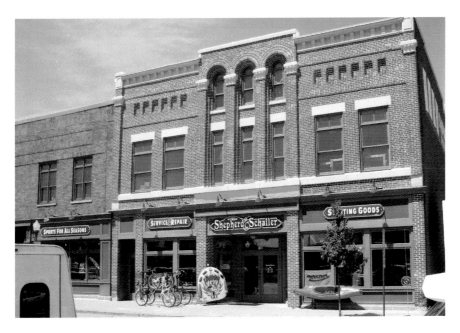

Shepherd & Schaller Sporting Goods on Scott Street in Wausau.

in the basement near the bricked-off entrance to the tunnel that used to lead to the Wausau Club. We were unable to re-create the anomalous reading, leading us to believe that it may have been caused by something paranormal.

The next investigation was in October 2009, when again the WPRS was approached for a Halloween feature. This time, we were accompanied by a reporter from a local newspaper, the *Wausau Daily Herald*. During the course of the investigation, we set up four DVR cameras in various locations throughout the building. About an hour into the investigation, we discovered that all four cameras had become unplugged, seemingly by themselves. Was Eddie with us that evening, still burning the midnight oil?

IN THE DOG HOUSE FOR ETERNITY

There was a jumpin' little joint called the Dog House Bar & Grill located on Highway A in the town of Bryant, Wisconsin. No one is quite sure when the original building was constructed or exactly what its original purpose was, but stories abound. It looked to the investigators of the WPRS that the building had probably been constructed in the 1930s or '40s. Longtime customers and local town gossips claimed that it had originally been used as a speakeasy, those private clubs used to circumvent the evils of Prohibition. Previous owners were also reported to have had connections with Al Capone and of operating a safe house for him and his cronies.

None of this can be proven, but what is certain is that in the 1950s it was known as the Cresent Club and in 1962 it was converted into a bar and supper club. It operated as such until 1998, when the business closed down and the building lay silent for six years. Near the end of 2004, new owners purchased the building and started the tedious process of cleaning and renovation, officially opening the Dog House Bar & Grill for paying customers soon after.

The new owners immediately began encountering strange and eerie activity. When in the basement area, which had been used as a bar and dance floor years earlier, the owners reported cold spots and the feeling that there was a strong presence in that area. At other times, items that had been left in the upstairs areas of the building were lost, only to be found later in the basement with no logical explanation for their

disappearance or eventual reappearance. Lights throughout the building were found burning even though they had earlier been turned off. And on New Year's Day 2005, in plain view of owners and customers alike, a two-pot commercial-sized steel coffee maker flew off a counter and crashed to the floor. Perhaps it was a former bar patron who'd never left the old bar, demanding beverages of an alcoholic nature. Possibly the strangest of all was when the owners found an unspent .38-caliber shell placed gingerly by unseen hands in the middle of the kitchen floor. It hadn't been there earlier when the area was cleaned and the floor passed over several times.

The WPRS investigated the building twice, first on March 12, 2005, and again on June 4, 2005. During the first visit, investigators also felt the intense presence in the basement area, and separate pictures taken in that area revealed a large, incandescent orb and one dark, almost pensive-looking shadow figure leaning against a basement wall. Perhaps the entity was doing a little research itself? During the second visit, the WPRS brought along a female psychic who noted the energies of two separate male entities in the basement.

Interestingly, the psychic picked up on the presence of a stocky, balding man in his late fifties named Charlie who walked with a limp and was partial to flannel shirts with the sleeves rolled up. Charlie was thought to have "died about ten years earlier of a possible heart attack." She also felt the presence of a young boy who was searching for someone named Tommy. "This child spirit was dressed in turn-of-the-century clothing and had blonde hair that was cut in a bowl style." She said that the spirit was a very negative energy. The psychic also stated that she "saw an image of the young boy sinking to the bottom of a lake or pond" and she believed that he had been the victim of an accidental drowning. Coincidentally, another sensitive had previously mentioned to the owners that the basement held the spirit of a young boy who drowned on site.

The Dog House Bar & Grill wasn't just an old joint on the outskirts of town. No, it was more than that to its loyal customers. It was a welcoming tavern on the side of the road, a chance to chat with old friends, a midnight rendezvous with love and desire. If you can find it, step inside the Dog House Bar & Grill and kick your heels up. But make sure you don't do anything to get yourself put in the doghouse, because at this place your punishment could last for eternity.

HAUNTED HALLOWEEN ATTRACTION

An hour west of Wausau sits a haunted attraction where Halloween thrill-seekers may get more than they bargained for. Located within two large warehouses, the haunted house has over eight thousand square feet of horrifying monsters and scenes to make you feel squeamish.

In the late summer of 2008, the owner of this terrifying attraction called the WPRS with concerns that his haunted house may actually be haunted. The activity started after a recent purchase of slightly used coffins and repossessed tombstones. The coffins were artfully arranged in an imitation crypt, with tombstones nearby to give the effect that one was walking through a darkened graveyard. One morning, the owner arrived to find that the coffins had been mysteriously opened overnight. In that very room, several days later, the owner was putting some finishing touches on the scene when he heard his name called. The voice sounded as if it were coming from inside one of the coffins. He searched the building but found that he was completely alone.

The haunted house has a circuit box that runs its lighting and animatronics. One evening, a worker at the attraction shut down the circuit box and left the room. Returning after only a few minutes, he was shocked to see that the box had been sealed shut with duct tape. He was the only employee still there that evening.

In another room of the haunted house was a funeral parlor scene with an open coffin and gargoyle statues atop a piano. One afternoon, as workers arrived to start up the attraction for the evening, they discovered that one of the gargoyles had been smashed on the floor with such force that it was in hundreds of tiny pieces. Pieces of the statue were all over the room, some even landing back on top of the piano.

It was in this funeral parlor room that, while investigating during a cold and snowy November night, a WPRS investigator felt a strong tug on the back of his jacket. Thinking it was a fellow investigator, he turned to find that the nearest person was on the other side of the room. Could the tug have come from the spirit that caused the gargoyle to disintegrate?

During the same investigation, while alone outside the building, an investigator felt someone walk up behind him. As he turned to greet this newcomer, he heard a woman's voice sigh in his ear. There was no one there.

It seems possible that real phantoms are roaming alongside this haunted Halloween attraction's bloodcurdling imitations.

STAGE FRIGHT

Like most theaters, the former Rogers Theater (most recently the Fillmor Night Club) is no exception to the rule when it comes to claims of being haunted. The former theater has been the site of various unexplainable phenomena and also host to several personal accounts and stories that have been told over the past several decades. Most of these stories are firsthand accounts that have been obtained through local lore, e-mail messages to the WPRS and interviews with workers of the former theater. However, some experiences have stemmed from several of our investigations at the site. Apparitions, electrical disturbances, physical manifestations and the feel of veiled forces are all but commonplace. The former theater is well known in the area and is an important part of the community. Located at 310 North Fourth Street in the historic downtown Wausau area, the theater has played host to a variety of tenants over the years.

It is unclear what year the original building was built, but directories point to sometime around the first decade of the twentieth century. Records show that the building was first utilized as Ammenthorp Tire Shop, with apartments located on the second-floor level. Although not verified, it was rumored that during the early 1920s a woman was murdered in one of the upstairs apartments. In 1926, Helke Furniture—which had been located across the street from the Fillmor—acquired the property, and it then became Helke Funeral Home. Helke had already been building upholstered coffins for decades, so it seemed a natural transition to expand its business. Helke was also the first funeral home in Wausau to provide embalming. The funeral home operated there until about 1939. The building lay vacant for a number of years; however, it was reportedly used as a brothel during that time. In 1945, it reopened as the Hollywood Theater, and then in 1960 it became the New Wausau Theater. In 1979, it opened as the Rogers Theater and operated as such until 2002. The Rogers took up new ownership in 2005 and was renovated to reopen as the Fillmor Night Club. The nightclub opened its doors in 2008 and closed in 2009. The building now lies vacant with a very uncertain future.

Although the Fillmor officially closed its doors, many feel that the former theater and nightclub is still a flurry of activity. Several ongoing investigations were conducted by the WPRS between October 2003 and July 2007. The findings in 2003 were minimal and non-paranormal. What drew our interest at the time was the fact that many witnesses had reported similar incidents in the past. Since that first investigation, several more eyewitness accounts have

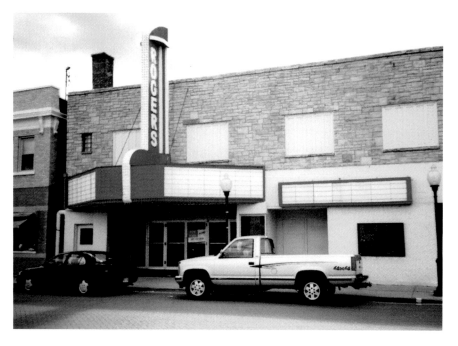

The Rogers Theater, one of Wausau's most haunted sites.

surfaced. When we were asked to return in December 2005 to do a more extensive investigation, the findings were much more than nominal.

The strangest reports seem to emanate from the basement auditorium area. Former employees commonly referred to the spirit there as "Bob," but how that name came to be is unknown. One of the first reports was from a former employee who was working alone in the basement auditorium. He had gone to the basement to set up the film for the evening in the projector room. While setting up the film, he saw a man dressed in a black suit cross the stage area. He checked the theater thoroughly, but no one could be found and the doors were closed and locked. He continued his work in the projection room only to be frightened nearly to death when the same man in the black suit was staring at him through the projection window, his face blue in color. The employee screamed and fell against a metal shelf, knocking several film reels to the floor. He lay there for about ten minutes, terrified, before he found the courage to leave the booth and exit the building.

Another account tells of two former employees who were working alone in the basement auditorium removing rows of theater seats from the floor.

Both men heard a thumping sound from the stage area, and when they looked up, they noticed that the first row of seats was bouncing. At once the men threw their tools to the floor and hurried out of the building, with the seats rocking violently behind them as they ran. Both employees did not return that evening and refused to work alone in the building after that. On two separate occasions the night manager was locking the front door for the evening when she was "pushed" from behind by imperceptible forces and fell to the sidewalk. Several other notable phenomena have occurred during the past three decades, such as lights turned on and off by unseen forces, reports of rapping noises that cannot be explained, unexplainable sounds and whispers, items being moved from one place to another, the sound of someone sitting down in the theater chairs with no one else present, strong feelings of a presence, and the marquee lights turning on and off by themselves when the building is not occupied. Several times during matinees all five of the film projectors would turn off within seconds of each other, and when later checked by an electrician, no malfunction could be found.

In December 2005, the WPRS returned to the site to perform a more thorough investigation of the building. We used several different types of instrumentation, such as electromagnetic field meters, temperature probes, tape recorders for electronic voice phenomena and night shot video recorders for recording in total darkness, as well as several other pieces of equipment.

During this investigation, we experienced a multitude of unexplainable phenomena. Photographic anomalies were captured, but we are unable to verify without a doubt that they are paranormal in nature. One photograph taken in one of the upstairs auditoriums has the image of a large orb. The orb seems to have mass with a transparent quality to it. An orb such as this may be the manifestation of spirit energy. It seemed to emit its own light, which is typical of an authentic orb and the type that paranormal researchers look for when investigating.

Several researchers in our group conducted EVP sessions in the upstairs auditoriums during the evening, with unusual results. One session captured a female voice singing the words "pray for you." This voice was not heard by anyone during the recording. Just after that voice is heard on our tape, three researchers from the team witnessed a theater chair rocking on its own. One researcher attempted to take a photograph of the chair and encountered a total loss of power to her camera. Later examination of the camera's batteries showed that they were completely drained of power. Interestingly, the batteries had been placed, fully charged, into the camera

Anomalous photograph taken in a basement stairwell of the Rogers Theater.

at the beginning of the investigation. Several attempts were made by the entire team to try to replicate the bouncing chair anomaly, with no reasonable result. Also, other EVP sessions conducted in the basement and upstairs theater areas captured more unexplainable voices. The second session captured the words "Jesus Christ" whispered very clearly. Other EVPs that were captured could not be clearly understood.

The team encountered on several occasions unexplainable spikes in EMF coming from the second floor, hallway and projection booth areas. These spikes could not be replicated and could possibly be paranormal in nature. During our vigil, the EMF meter sporadically reacted to a changing magnetic field. The source of this could not be found by WPRS investigators.

One researcher, while on the second floor, heard what sounded like a male voice. Two other researchers were present when this took place but did not hear the voice. What may be coincidental was the fact that just prior to hearing the voice, investigators had asked a question while conducting an EVP session. The team tried to replicate the voice to see if it was caused by stray noise but could not find any explanation.

On our third investigation of the Rogers Theater, we decided to start by conducting a walk-through of the theater to obtain base line readings

and determine if any areas had more activity than others. Personal observations by all present indicated that a strong feeling of presence was felt in the basement auditorium. We decided to focus our attention there and upstairs in auditorium #3, where on an earlier visit we had experienced paranormal activity. During the early part of the evening, one of our investigators became so fearful in the basement auditorium that he was not able to continue with the investigation. EVP sessions were conducted in the basement auditorium, as well as in auditorium #3. Review of the recordings in the basement revealed a low whispered male voice saying, "That'd be cool. Shawn get out." What is meant by that statement is unclear with the exception of "get out." The other EVP was of a very low, gruff male voice, but it was unintelligible. The voices were not heard by the investigators who were present during the recordings.

During our fourth investigation, one of our investigators noted that he felt as if he were being watched when he first entered the lobby area. He also felt the same way in theater #1. Another investigator noted that he felt a presence near the top of the steps leading to theater #3. At the same time, he saw a slight movement out of the corner of his eye that was described as a shadowy spiral movement. Perhaps coincidence, an EMF meter seemed to react at times to questions that were asked. Video footage taken at the site showed only a brief moment when the camera unexplainably went out of focus. During the EVP session in the basement level, we captured on audiotape a male voice saying, "Oh…Are we here to tape?" None of the investigators present heard the voice while taping, nor did the voice sound similar to any male members of the group. Also, the question itself did not make logical sense, as all of the crew realized that we were taping. Interestingly enough, just weeks prior, a low-budget movie had been filmed in the theater. Maybe the entity thought that we were the movie crew coming back to do more filming. Given the outcome of the investigations at the former theater, we believe there is paranormal activity present at the site.

Recently, we received reports from the owners of the Fillmor. One evening, an employee of the nightclub reported that he had encountered a woman dressed in white with dark hair wearing a very distinct black ring sitting on one of the old theater seats in the sound booth. When he looked away and back again, she was gone. Undoubtedly, the unsettled spirits in the building will continue to occupy the site regardless of its human occupancy.

OPEN FOR BUSINESS

At the corner of Fourth and Jackson Streets in the city of Wausau, Wisconsin, you'll find a little eatery called Erbert and Gerbert's where you can get a great sandwich and a giant deli pickle to go. The three-level white brick building was the original Adams House, a charming hotel built in the later part of the 1800s that sported large, pleasant rooms and friendly accommodations. After its use as a hotel ended, the building went on to service the community in several different business incarnations, such as a millinery store, tailoring and shoe repair, building and loan, various governmental and law offices, bread market and a domestic violence program, among others.

The current restaurant has occupied the building since 2004, and from all accounts you may be ordering more than you expect when you choose to dine here, for it is widely rumored by staff and patrons alike to be haunted. The sandwich shop is located on the main level of the building with the basement used for storage, while the top floor remains vacant. Or does it? Restaurant staff has reported hearing creaky footsteps crossing the second floor when no one is upstairs. And several employees have seen what appear to be dark specters in their peripheral vision that vanish when they turn to get a better look.

World War I doughboys during a Wausau holiday parade. The Adams House is in the background.

Erbert and Gerbert's Sandwich Shop.

If the second floor is sometimes noisy, the basement has its own pranksters. The door to the basement is said to open without the aid of living hands again and again. This reportedly became such a nuisance that staff eventually padlocked the door just to keep it shut. But even padlocking the door didn't keep the resident entities from playing hide-and-seek with restaurant paraphernalia, for items have been known to disappear into thin air only to be found in some totally unexplainable place at a much later date.

Maybe that's what happened with one customer who got away. A male waiter was working the late shift one evening when he heard someone come into the restaurant; the doorbell trembled as the front door opened, and footsteps were heard crossing the floor. The employee hurried to the front counter to take the customer's order, but no one was there. He made a quick search of the restaurant, yet the errant customer was never found. Now if that's not enough to entice you to make your order "to go," maybe hearing untraceable disembodied voices will convince you to hold the pickle and the lettuce and beat a hasty retreat to the street.

EXTENDED STAY

On the corner of Scott and Third Streets in downtown Wausau stands the stately Landmark Building, once the tallest building in the city. The Landmark began as the luxurious Hotel Wausau in the 1920s, but the location holds a history dating back to 1881.

George and Mary Jane Bellis moved to Wausau in 1873 to set up shop as confectioners. Before long, Mr. Bellis noticed a need for a hotel in the area, and he opened his first, the Arlington Hotel, in 1875. In 1881, he built the Hotel Bellis on the site where the Landmark Building now sits.

The Hotel Bellis was constructed of red brick, adorned with large windows and iron railings. It boasted sixty rooms, which all came equipped with bathrooms, electric lights and telephones that could ring the front desk. Guests also had the luxury of being transported to and from Wausau's train stations via an omnibus, which was a windowed car pulled by horses. The Hotel Bellis was considered to be the utmost in class and sophistication.

Mrs. Bellis took great pride in the hotel's one-hundred-seat dining room and did much of the cooking herself. A menu from the early 1900s lists items such as cornmeal mush with cream, kippered herring and ox tongue.

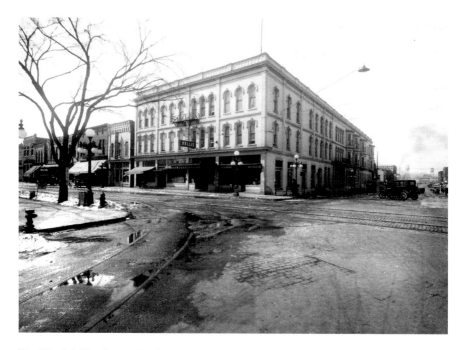

The Hotel Bellis, circa 1920. *Courtesy of the Marathon County Historical Society.*

Mr. Bellis passed away on December 30, 1904. His funeral service took place in the lobby of the Hotel Bellis. After his death, the hotel was run by his sons, Mark and Newman.

A $5,000 renovation on the hotel's front entrance took place in 1914 in order to make it appear more modern. This modern look was short-lived, however, as the Hotel Bellis was demolished in 1924 to make room for the Hotel Wausau.

Construction of the Hotel Wausau began on September 17, 1924. Considered one of the most elegant hotels in the country, the Hotel Wausau was built by Walter Schroeder at a cost of $1.5 million. The nine-story hotel was built in the Neoclassical architectural style, with an exterior of granite and cut stone.

On Friday, July 17, 1925, the Hotel Wausau held a grand opening for Wausau and Marathon County officials and their wives. A dinner featuring medallion of English sole was served, followed by dancing in the majestic ballroom. Music was provided by the Badger Room Orchestra, and the guests of honor were entertained by vaudeville performers from Milwaukee and Chicago.

The Hotel Wausau was in operation until the early 1970s. After it closed its doors, the building was renovated into family apartments and was renamed the Landmark Building. A variety of shops operate on the former hotel's main floor.

When looking at the Landmark Building, it isn't hard to believe that ghostly activity takes place within its shadowed hallways. Over the years, several distraught people have met their deaths by jumping from the upper-story windows of the old hotel. It's possible that the building holds on to the negative energy felt by those poor souls who saw no other way out.

Cold spots, thought to occur when a spirit tries to manifest, can be felt throughout the Landmark, and some residents report an uneasy feeling that seems to emanate from the walls. Residents also experience things being moved in their apartments, such as pictures being placed face-down.

The full-body apparition of an elderly woman in a floral dress and pearls has been witnessed many times over the years. She is seen sitting on a chair near the former hotel's back entrance. When approached, the woman stands, walks away and vanishes into thin air.

One former resident remembers that she would often be drawn from her apartment by the sound of someone playing beautiful music on the old piano still kept on the first floor of the building. She would stand on the second-floor landing and listen, but as soon as she descended the stairs, the

The former Hotel Wausau, now the Landmark Apartments. *Courtesy of the Marathon County Historical Society.*

piano would be silenced and she would find the lobby empty. Many other people have heard music, like that which was popular in the 1920s and '30s, playing in the hallways of the Landmark Building. When investigated, the source of the music cannot be found. Maybe, after all these years, guests of the Hotel Wausau are still enjoying their stay.

GRAVEYARD SHIFT

Having been a former worker in the field of security, this writer can say without hesitation that it is often thought of as boring, mundane and monotonous work. But once in a great while it can be exciting or even, in this case, quite frightening. Of course, this all depends on your point of view and your level of bravery. This true story comes from the former J.I. Case factory located in Schofield, Wisconsin, which is now the Merrill Iron & Steel Corporation. It was at that factory where a night watchman experienced what is commonly referred to as poltergeist activity. The word comes from the German *polter* (to knock) and *geist* (spirit). Webster's dictionary defines it as a mischievous ghost thought to be responsible for unexplained noises.

For some time, there had been numerous reports of ghostly activity within the factory walls. Security staff had even been told of some experiences their co-workers had, but they didn't really believe them to be true. This particular security guard had been working at the factory as a night watchman for the past three months and hadn't seen anything unusual. He put the stories out of his mind as he went about his normal evening rounds. He would usually use the company car to get to the first of several buildings on his round, as it was a great distance to walk and he had many buildings to check on the factory grounds. He pulled up to the first building and exited his car. It was a cold night, and the snow crunched under his feet as he hurried toward the building. While walking, he heard a noise that broke the late-night silence. He looked toward the building and noticed one of the overhead doors opening up. At exactly the same time on the other end of the building another overhead door was opening. Once the doors were open, he heard the distinct sound of hammering and factory work coming from within the building. He did not see any lights on inside the building and thought it odd that employees were there so late working in the dark. Normally factory personnel did not work during his shift. He entered the building to check out what was going on. As he entered the area, the sounds of working stopped. A further check showed that no one was present. Suddenly, both of the overhead doors began to close of their own accord. The guard proceeded out a side exit to check if maybe someone had just left the building, but there was no sign of anyone, no fresh footprints in the snow and all was quiet. He again checked over the building to make sure it was secure and then left the same way he had entered. Once outside, he again heard the hammering noises and voices of men working within. He returned a second time and the sounds at once stopped, just as before. The security officer

was very unnerved and decided to leave in a hurry and finish the rest of his rounds at the other buildings. To his relief, he saw nothing else unusual that evening. The next morning, he reported the malfunction of the doors to his employer. An electrician checked them out and found nothing mechanically wrong with them.

A few months had passed since these strange occurrences. The security guard was again in the same building performing his normal rounds and duties. As usual, no other workers were present and the building was dark and quiet. He walked by a work area where a metal tray with raised edges was lying. Inside the tray lay a large metallic bolt, and as he passed the area the bolt began to move and flipped out of the tray to the floor. This startled the guard, as he could find no explanation for what had happened. He continued on his round, but quickly, of course. He came to an area near the overhead doors where several pallets were sitting with very heavy machinery on them. He heard a noise and saw one of the pallets lift off the floor about six inches and then fall back down again. At this point, the guard became very frightened and ran out of the building. He did not return that evening. He was relieved that he never experienced any strange activity again while working there. However, many employees reported the same experiences while working in that building long after that security guard had moved on.

Many years later, the WPRS was notified by a family member of a man who had once worked for the former J.I. Case plant. They had read this very story on our website and relayed to us that their father passed away at the plant in 1980 due to a forklift accident. He died in the same building where these paranormal occurrences took place. Was the spirit of this deceased father still trapped in the factory? Did he not realize that he had died that day so many years earlier? We hope, for the sake of the family, that he has since moved on to the afterlife. But who were the phantom workers, and why were they there? We may never know.

FRATERNAL PHANTOMS

Rumors of ghosts roaming the ballrooms of the Elks Club Lodge have circulated for many years. While the building, located on the corner of Scott and Fifth Streets in downtown Wausau, was built in 1923, the land it sits on has a longer history.

The site was once home to lumberman John C. Clarke. Clarke moved to Wausau from North Wales in 1845 at the age of fourteen. Over the course of his life, he went from being a Wisconsin River pilot to a much-respected lumber mill owner.

In the mid-1850s, Clarke married Rhoda Jane Putnam. Together the two had eleven children, only five of whom survived into adulthood. It was to accommodate their growing family that Mr. and Mrs. Clarke built a beautiful home in 1875 at 414 Scott Street. The home was built in the Italianate style and boasted a third-story tower and many embellishments. It was touted by the local paper, *Central Wisconsin*, as one of the finest homes in Wausau.

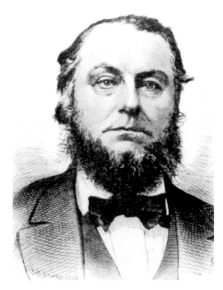

John C. Clarke. *Courtesy of the Marathon County Historical Society.*

Clarke was a notable citizen of Wausau, holding many public offices. In 1859, he became sheriff, was chairman of the County Board in 1863 and was mayor of Wausau in 1877.

In 1884, Clarke sold his home. It remained a private residence until 1905, at which time it became home to the Wausau Sanitarium. The sanitarium was owned and managed by Dr. Augustus C. Lucas, physician. Not much is known about Dr. Lucas or the Wausau Sanitarium, as it was only in business for two years.

The Benevolent and Protective Order of Elks #248 purchased the Clarke house in 1914 and used it as its lodge until it was razed in order to make room for the current lodge. The current lodge was built by club members in 1923, for a total cost of $130,000. Every task—including construction plans, building, decorating and furnishing the lodge—was performed by members of the Elks Club. The architect, William Oppenhammer of Oppenhammer and Obel, was an Elk at that time. Other prominent Elks Club members were G.B. Heinemann, Carl Helke Jr., Rufus P. Manson and A.B. Rosenberry.

The cornerstone was laid in June 1924, and the lodge was dedicated in September of that same year. The building boasted six bowling alleys, a

Wausau Elks Lodge #248.

billiard hall, card rooms, a library and a 4,758-square-foot dance floor. It was lavishly furnished and decorated in Elks colors, purple and gold.

The dedication was presided over by John G. Price, grand exalted ruler. The Elks ladies served three courses, and music was provided by the Elks Orchestra, which played several encores.

Many people have had personal experiences with the unknown in the Elks Club Lodge, including the lodge historian, who, while in the basement bowling alley, distinctly heard the sound of heavy furniture being moved above him in the banquet hall. When he went to check the hall, there was not a soul to be seen, and the furniture remained untouched and in its rightful place.

A frequent occurrence in the basement of the lodge is the mysterious appearance of poker hands lying out on a table in what was once the club's card room.

There have been many reports of paranormal activity in the lobby of the Elks Club. People often find themselves inexplicably drawn to the mirror in the main hall that hangs directly over the carved Italian walnut fireplace mantel. Cold spots have been reported in this area as well. One

club member, in the summer of 1998, was exiting the first-floor bathroom into the lobby when he felt a force try to lift him into the air and push him from behind.

The club's business manager was working one Sunday evening in late 2001 when he encountered what may have been a hostile spirit. He had locked up the building, and was alone in his office, when he was suddenly overcome by a sense of foreboding so oppressive that he felt as if he were being reprimanded by someone unseen.

Not all Elks Club specters are so disapproving. Patrons of the first-floor bar may find themselves sitting next to a man in a white sports coat. He appears out of nowhere and raps his fist on the bar, seeming to request service.

Employees report hearing footsteps and feeling a presence in the second-floor ballroom. In fact, newcomers are often told to expect encounters with this ghostly presence and are assured that, should they hear the footsteps following them across the empty ballroom, not to worry, "he's okay."

During an investigation in 2002, the WPRS experienced firsthand the strange feelings often reported in the lobby. Investigators also had the distinct feeling of being watched while near the stage area in a third-floor ballroom. Tapping, bumps and other unexplainable noises were heard during the investigation.

Are the children of John and Rhoda Clarke still lingering in their childhood home? Perhaps these are ghosts of former Elks who built the lodge with their own two hands? One thing is for certain: the Elks Club Lodge stands as a testament to the pride and dedication of its founding members.

The Voice from Beyond

It has long been theorized that spirits stay behind for a reason. Many think this is due to some earthly attachment or fond memories of a place or past event. Others feel that sudden death leaves a soul trapped in a state of perpetual confusion. And numerous people believe that unfinished business creates an atmosphere conducive to hauntings. Whatever the reason may be, this particular spirit has decided to stay on in the afterlife in his former home. While it is not possible to know exactly who haunts a location, it's possible that the owner who lived there the longest may be the residing spirit.

The property was first purchased from the U.S. government in July 1886 and changed hands many times over the next seventeen years. Finally, in 1903, a home was built on the property. The property again changed hands many times over the next one hundred years. The home still holds a certain grace to it, although changes have been made to the structure. What was once a moderately elegant home has now been converted to a business. The current owner purchased the home in 2000 and has operated it as such since that time. From the moment she moved in, she sensed something unusual in the old house. Often when working by herself in the building she noticed that she never felt alone. The presence did not feel malicious but rather comforting, and the owner soon became accustomed to her unseen companion. Months turned to years, and the unseen presence never seemed to wane.

One day while the owner was sitting at her desk in the main lobby area, she looked up and thought she saw movement in the adjacent hallway. Thinking she was just tired and that maybe her eyes were playing tricks on her, she went back to her paperwork. A few minutes passed, and again she saw very fast movement in the hallway from right to left. The movement, at a glance, looked like a human figure but without any distinguishable features. She waited and watched closely again, but the specter did not return that evening. Several months would pass before she would encounter the apparition again.

One afternoon while another worker was in the front entrance area nearer the staircase, she looked up toward the second-floor landing. When she looked up, she noticed a white-colored undefined shape move quickly right to left across the upper staircase landing. Employees would witness both phantoms many times over the years. Sometimes employees would see things out of the corners of their eyes in other areas of the house. Whatever was being seen did not frighten anyone, but rather became an accepted fixture in the home. People grew used to the strong presence.

Several years after moving in, the owner spoke with the prior family that had lived in the home for quite some time. They told her that they had seen the ghost of a nun in the house often throughout the years. After doing some research, no nun was ever found to live at the residence, but a church located directly behind the home may be the source of the ghostly nun. Perhaps the church used the land prior to the home being built there. Neither the current owner nor her employees has ever seen the nun.

On other occasions, workers in the home have experienced strong feelings of grief and sadness. One can only surmise that these feelings are perhaps

left behind from a prior traumatic experience. Sometimes workers would also hear a large thump coming from upstairs when downstairs and from downstairs when they were upstairs. The source of the sounds could never be found. Also, items would be moved from one place to another with no explanation as to who moved them; sometimes they were even found broken. It seemed like the unseen visitors liked to play harmless pranks on the staff in order to keep them aware of their presence.

In October 2009, the WPRS was contacted by the owner and asked to investigate the activity. During the investigation, several WPRS members tried to contact whoever was present in the home through the use of EVP. Sessions were conducted in the sitting room off the main hallway where movement has been seen several times by the owners. An EVP session was also conducted in the main lobby area. The EVP obtained was not heard during the recording, but upon playback three male sounds were heard. One voice was unintelligible, and one sounded as if it said "yes." However, the most audible voice was heard on the recording when we asked if they had any messages they would like to give us. The response: "Get out." Perhaps the ghostly spirit that resides in the home feels comfortable with its current owners and wishes to stay on without interference. For now, the ghosts have been left in peace and the current owner is content with their presence.

ANNIE AND THE BLUE COWBOY

The University of Wisconsin–Marathon County (UWMC) sits nestled among tall pines next to the seventy-eight-acre Marathon Park in Wausau, Wisconsin. The original school building was completed in 1902 to give a permanent location to the County Normal School, which was a training school for teachers. The school graduated about 1,444 teachers during the next forty-three years, most of whom went to teach in rural schools.

While many of us love our jobs, how many love their jobs so much that they choose never to leave? This is the case for Annie, a female custodian who worked for UWMC during the 1970s. Annie was widely known for her distinctive laugh, reported by co-workers as sounding like "a chicken cackling," and she started each and every workday with a cup of coffee and pleasant conversation with her fellow custodial employees in the university cafeteria. Annie is said to have died of throat cancer, but it is widely believed that she never left the university campus.

University of Wisconsin–Marathon County Campus.

Shortly after Annie's death, people started to hear her cackling laugh in the building. On more than one occasion, employees and customers inside the cafeteria claimed that they heard the woman's distinctive laugh. It was reported that the library director, while inside the cafeteria, heard the eerie cackle of Annie and, one can only assume questioning her own sanity, turned to a nearby custodian and asked if he had heard the cackling laughter as well. He had.

Annie, the ever-vigilant custodian that she remains, does not spend her entire day in the cafeteria. Custodians working the late shift after all the classrooms have emptied have reported hearing footsteps and chairs being dragged across the floor above them. One custodian related the following story: "We would hear footsteps coming from the hallway above the break room and a couple of us would run up different staircases to try and trap whoever it was between us, but when we reached the top of the stairs there would be no one there. This happened quite a lot." Another custodian said, "Sometimes when I am in the break room at night I hear the sound of what sounds like a wooden chair being dragged across the tile floor above, but when I go up to check it out there is nobody there." Or is there?

Kitty-corner from the main classroom building where Annie continues her rounds sits the UWMC Residency Hall, a small student residency building.

The Ghostly History of Big Bull Falls

This brick building has been rumored to be haunted for as long as anyone can remember, and from one year to the next, former and current student residents pass on stories of ghostly activities. This unassuming building is reported to be the stomping grounds for an apparition known as the Blue Cowboy. A male apparition wearing a cowboy hat and oftentimes noted as having a blue aura has been seen by various people between the hours of 2:00 a.m. and 3:00 a.m. in the residency hall. Not only has he been seen walking in the third-floor north hall, but he is also said to haunt a particular room on that floor, Room # 308, where he has been seen walking out of the closet and through walls. This same room has been reported to reverberate with knocking noises and the sounds of furniture being moved from within its confines. Upon investigation, no one is found in the room, but the furniture has been rearranged.

While the Blue Cowboy roams the upper levels of the residency hall, the basement has its own occupant, an old woman who haunts the basement and laundry room area. As evidence, a student offered the story of his friend who was in the basement one night and suddenly felt a cold chill. He turned around just in time to see a white figure floating up behind him in the damp and musty enclosure. Rumor has it that he had to wash a second load of laundry that night.

University of Wisconsin–Marathon County Residency Hall.

THE STARTLED SPECTER

Factories are usually thought of as places that are busy, fast-paced and full of life. But to most workers it is probably the last place they would be caught dead in. However, the dead are still around at Kraft Cheese. The building was used as a meat packaging plant for many years. In 1927, the site was purchased by J.L. Kraft from the Farmer's Cooperative Packing Company. The building was then converted to manufacture malted milk. In 1928, its name was changed to Phenix-Kraft Cheese Company, and additions and expansions were added in 1940, 1963 and 1970. A fourth and fifth floor were also added to the main building in 1958. Today, the plant is still in operation as an aging, final processing and packaging plant.

The first report of paranormal activity was in November 1995. A worker had been at her job as a night security officer for almost four hours, and it was time again for her to complete her rounds of the building. It was a Saturday night, and the factory was shut down and quiet for the weekend. The officer started her rounds on the first floor and proceeded to the second and then third floor. She went to her first checkpoint located on that floor. She had to pass through a small room to reach the main hallway that leads to that area. As she worked her way down the hallway, she was suddenly startled by a woman standing at the other end. This caught the officer by such surprise that she screamed and jumped back. Remarkably, it appeared that the woman was scared as well, because she too, had an expression of fright on her face. The mysterious woman made no sound and slowly began to back away from the officer until she dematerialized through the wall directly behind her. The ghost the officer had seen appeared to be in her late thirties or early forties with light brown hair that was braided back. She was wearing turquoise-colored business attire consistent with the late 1960s or early 1970s. The woman had appeared to be semi-transparent. This encounter left the officer absolutely terrified. She made her way down the hallway and took the exit back down to the first floor. The officer decided to stay at a central location that was well lit and refused to complete any more rounds that evening. After this happened, she always felt very uneasy on the third floor. The officer never saw the ghostly woman again while she worked at the building.

A few weeks had passed since the officer had seen the unknown woman. Another officer who had heard about the incident was working alone on his shift. It was about 4:30 a.m., and it was time for him to complete a security check. He followed nearly the same route to complete his tasks

as the other officer had. Once he had completed his first checkpoint on the third floor, he entered the same area where the other officer had seen the eerie frightened woman. The officer entered the lab room and was suddenly hit by a rush of very cool air that blew papers to the floor and made his hair stand up on the back of his neck. He then heard the sound of a person moaning and screaming as if in agony. Down the hallway he saw a very small, dark figure shuffle toward the other end of the hall. The unnatural figure was draped in what looked like a black cloak, and its face appeared to be burned or deformed and appeared almost inhuman. The figure shuffled away down the stairs and out of sight, moaning as it went along. The officer was scared to death of what he had just seen, and he was more than anxious to leave work that morning. A few times after that incident, he saw machinery turn on without the aid of human hands, and workers told him of seeing misty white figures on the shipping docks.

About four years later, another worker was on the third floor near the same area where the ghostly activity had taken place. While there, he saw a misty white figure form and float down the hallway past him and then dissipate into thin air. To this day, workers still report strange occurrences within the walls of the factory.

Nightingales of Old Hospital North

Commonly referred to as Old Hospital North, the former St. Mary's Hospital sits atop a hill on Wausau's east side in an area known as Forest Park. The old hospital has a rich history, as well as a reputation for being haunted.

St. Mary's Hospital began in 1905, when Sisters Coletta, Ludmilla and Wyborada of the Sisters of the Divine Savior arrived in Wausau to assist Dr. Douglas Sauerharring. Riverside Hospital, the small hospital operated by Dr. Sauerharring, quickly proved to be too small to meet the needs of Wausau's citizens, so the sisters made plans to raise the funds for a new, larger facility. They did so by personally going door to door to ask for donations. The sisters were able to raise $5,000 in this manner. Another $5,000 was donated by Wausau's mayor, Robert E. Parcher, and the rest of the funds were raised through the sale of bonds and a no-interest loan. Construction of the hospital began in the spring of 1907 on land that was donated to the sisters by the Wausau Law and Land Association.

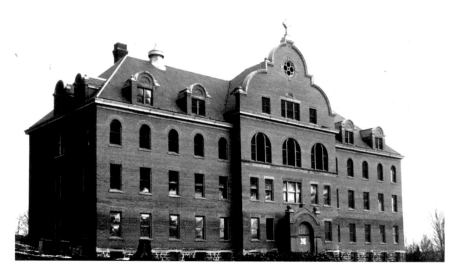

St. Mary's Hospital shortly after construction was completed. *Courtesy of the Marathon County Historical Society.*

Not quite six months later, on September 27, 1908, the new sixty-bed St. Mary's Hospital was dedicated. The Sisters of the Divine Savior went to work offering Wausau residents what they referred to as "Free Bed Service," which meant that everyone was given the same care and consideration, even if they did not have the means to pay. In addition to caring for patients, the sisters spent their time preparing meals, canning food to stock the hospital kitchen, cleaning, shopping for the hospital and laundering hospital linen.

St. Mary's Hospital quickly grew, and over the years there were many additions. A south wing was added in 1922 to house St. Mary's School of Nursing. The fourth floor was remodeled in 1935, and a north wing was added shortly after that, in 1941. In 1945, the Administration and Plant Operations building was added to the southern portion of the property.

In 1947, Parcher Place was built and used as a home for the Sisters of the Divine Savior. A communicable disease building, used to house patients with polio and tuberculosis, was built in that same year. The building later became the pediatrics unit. In 1961, the hospital added a dormitory for students of St. Mary's School of Nursing. The dorm, named Mary Hall, became a home for single women after the school closed its doors in 1967.

St. Mary's Hospital continued to grow throughout the '60s, with the Ridgewood building constructed in 1960 and a new, larger west wing added in 1968.

In May 1970, St. Mary's merged with Memorial Hospital, and the two became known as Wausau Hospital North and South. When a new hospital was built in 1979, it marked the end of an era, as the former St. Mary's Hospital was left vacant.

Many believe that the spirits of those who dedicated their lives to the care of others linger in the hallways of Old Hospital North. Most of the legends surround the Parcher building, once the home of the Sisters of the Divine Savior. Unexplained knocking can be heard on doors throughout the building, and dark figures are seen roaming the grounds.

People who spend time in Parcher Place experience an oppressive heaviness to the air and feel as if they are not alone. They may also get a glimpse of a ghostly security guard who is seen patrolling the hallways of the old building. Perhaps it is the security guard who turns on the fountain in the middle of Parcher Place, as it is often found running on its own. The elevator seems to have a mind of its own, moving from floor to floor without the aid of any living person.

The vacant communicable disease building also has its fair share of phantom activity. The windows of the building, always left securely shut, are often found wide open. Lights are turned on by unseen hands. Hospital beds, stacked away and long forgotten, have been found freshly arranged in rooms, as if the building is awaiting its next patient.

A nurse, wearing her 1940s-era white uniform and hat, has been seen walking up and down the halls of the communicable disease building. She is still hard at work, pushing her medical cart, caring for the sick and bedridden for all eternity.

Spirits of the Sanatorium

Over the centuries, many diseases have come and gone, some claiming millions of lives. Wausau did not escape unscathed, especially when it came to tuberculosis, formerly known as consumption. At one time, people believed the disease was the result of the infected becoming a vampire. This was due to the fact that the infected victim often portrayed signs such as swollen red eyes, blood around the mouth, pale skin and sensitivity to daylight. It was thought that this loss of blood would drive the infected to replenish their blood supply by sucking the blood of another. Thank God for modern science or we may have had mobs of citizens lining up for wooden stakes.

Staff and patients of Mount View Sanatorium, circa 1920s. *Courtesy of the Marathon County Historical Society.*

The disease was highly contagious and had a death rate of 50 percent if left untreated. Marathon County, as many counties did, constructed a special sanatorium to handle the cases of tuberculosis. In 1917, the Mount View Sanatorium was constructed on the site of the present Marathon County Juvenile Facility. During the early 1920s, a nurses' quarters was added so that staff could be on site on a twenty-four-hour basis. By the 1960s, tuberculosis had become much more treatable, so the nurses' quarters were converted into a children's shelter home. This was a continuation of a smaller shelter that was on site in the 1950s, started by Dr. Willard and previously named the Dr. Willard Children's Preventorium. It served in this capacity until the mid- to late 1980s, at which time the building was gutted and left vacant. Meanwhile, the shelter home was moved to a section of the old sanatorium. In 2005, the building was razed due to its deteriorating condition.

During the 1960s, the main sanatorium building was converted to a nursing home. The name was changed to Sunnyvale Infirmary and later to Mount View Manor. Many patients died at the site while it was a hospital, as well as during the time it was a nursing home. It is likely that some of these suffering souls, who may have not known what was happening to them during their final moments of life, have stayed behind in a continued state of confusion.

Some of the earliest reports of ghostly activity come from the 1980s, when the main building was utilized as a nursing home. A worker and her assistant had taken some of the residents outside for a walk in the nearby woods. Near the end of the outing, the two staff members collected the group and headed back toward the building. One of the staff noticed a man walking away from the group, so she called out to him. The figure did not respond, so she began to walk toward him, as his back was to her. She called out again with no response. Once she was close enough, she reached out to touch his shoulder, and all at once the man dissolved away in front of her.

Shelter workers in the 1980s and '90s had various experiences both in the main sanatorium and in the old nurses' quarters. Children would complain of being woken at night by unseen hands. Voices and sounds were heard that had no explanation as to their source. The WPRS had some of these same experiences in the old nurses' quarters when we investigated there in 2002. Other workers reported that almost on a nightly basis around 3:00 a.m. they would hear what sounded like an argument between two people. The exact words were unintelligible, but it was certainly an argument. The staff would search out the source of the noise, and it would seemingly dissipate. During our 2001 investigation of the nurses' quarters, we experienced an extreme spike in our EMF meter while in the second-floor sunroom. Moments later, another researcher experienced the same spike on his meter across the room. Possibly we picked up on a spirit and caught its movement across that room. Other staff during the '80s and '90s reported an uneasy feeling while in the basement recreation area. Most felt that they were not alone while in that area.

In 1997, the old sanatorium was razed to make way for the Marathon County Juvenile Facility. However, it seems that the activity has not ceased even though the physical buildings no longer exist. Staff has reported hearing the sounds of a woman sobbing uncontrollably. When they seek out the sound, they find none of the residents crying. They go back to their work only to hear the crying again. When they seek out the sounds again, they stop. Several others have witnessed a black shadowy mass move quickly down a hallway near the nurses' office. It seems to creep across the wall and right through a door. The shadow is about three to four feet tall.

On another evening, staff observed movement on one of the video cameras in that same hallway. The employee saw what appeared to be part of a leg move into the adjacent bathroom when no one was present in that area. All at once the camera experienced interference and went black. Staff also reported the sound of jingling keys, as if someone was coming down

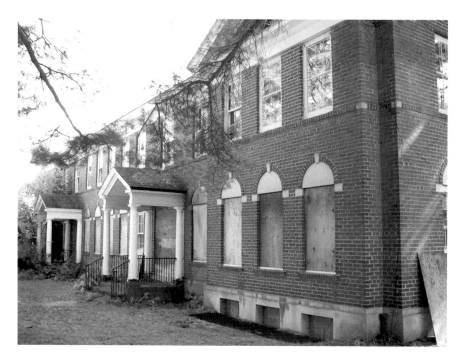

Mount View Sanatorium nurses' quarters in 2005, shortly before the building was razed.

the hallway. When they looked to see who was coming, they found that they were quite alone. On another occasion, an employee saw a co-worker in two separate locations outside at the same time via a CCTV. This is thought to be a doppelganger, defined as a spirit that takes on the form of a living person. Upon further inspection, the "twin" disappeared.

The restless spirits of the old sanatorium may continue to roam the grounds of the area, forever searching for comfort and questing for communication from the living. Perhaps someday their souls can be put at peace. Until then, the stories and encounters will continue and the dead shall not rest.

PART II

HAUNTED HOUSES

HOME IS WHERE THE HAUNT IS

The following story is a true account of author Shawn Blaschka's own paranormal experiences while living in his former home located in Wausau, Wisconsin. The exact address cannot be disclosed to protect the privacy of the current owners. Shawn and his family lived in the home from 1993 to 1999. During that time, they experienced several unexplainable events.

It was in November 1992 that my wife and I decided to finally move out of the small house we had been living in for the past two and a half years on the west side of Wausau. We had outgrown the one-bedroom home and had planned to start a family. So after a few months of looking around the area, we happened upon a home that both my wife and I felt very comfortable in. It was a bungalow-style home built in 1927. The interior was in good order, and the trim, doors and windows were constructed of solid oak, which gave the house a real warm feeling. The house was very out of date in some respects and was in need of a major face-lift, but it seemed sturdy and solid, with a large full basement under it, and we felt that we could transform it into a more than suitable home for our family.

In January 1993, we moved into our fixer-upper, along with one cat and two dogs. At the time, what we didn't know about the house was that we had also taken on an extra tenant—a ghost.

For the first two months, everything seemed very normal. Then strange things started to happen. The first of these odd events happened one evening when I was home alone. It was about eight o'clock at night, and I was sitting in the living room watching television. All of a sudden I heard the distinct sound of our kitchen cupboard doors closing. I turned the TV down and listened for a moment longer and noticed that the sound continued to come from the kitchen. The sound was distinct—a steel plate making contact with the magnetic clip that held the cupboard door shut. I got up quickly from the couch and proceeded to the kitchen. I looked around the corner, and the sound eerily ceased. I decided to check the cupboard doors and found them all closed firmly. Thinking that I was imagining things, I returned to the living room. Within moments of sitting down, I heard the same noise from the kitchen. This time I ran into the kitchen, again to find everything in order with not a sound to be heard. I decided to stay there this time and observe. I must have stood there for fifteen minutes or so when I decided that this was ridiculous, as nothing was happening. I again returned to the living room and sat down. A few minutes later, again I heard the cupboards opening and closing. This time I decided to yell out, "Stop it!" Upon announcing my wishes, the noise stopped, and it did not return that night. Over the next several months, I put the incident out of my mind and forgot about it.

Haunted home on Wausau's east side, circa 1996.

Several months later, I was working in the kitchen after supper. I was once again home alone while my wife was at work. Once I finished up, I turned out the lights and noticed the basement light still on. Thinking I had left it on by mistake, I turned it out. I went into the other end of the house to relax and returned to the kitchen a few hours later just prior to bedtime. Upon entering, I noticed light emanating from the other end of the room. I walked across the room to find out where it was coming from. As I looked down the basement stairs, to my amazement, the light was again on. On several occasions after this, lights turned out in the house would mysteriously be turned back on. Several times when my wife and I would return home from being out, the lights to the basement would be on with no explanation to be found.

One evening, my four-year-old son and I were working downstairs cleaning up around the furnace area. I replaced the furnace filter and stated to my son that soon we would need to turn the furnace on, as it was getting colder outside.

The next day upon returning home from work, I entered the house and was greeted by a blast of hot air. The whole house was blazing hot. I could easily tell that the furnace was running. I went to check the thermostat and found that it was set to eighty-five degrees. Normally when we set the thermostat we would set it between seventy to seventy-two degrees, but in this case we hadn't even turned the furnace on for the winter yet. The day prior, neither the thermostat nor the furnace switch downstairs had been turned on. My wife had not turned it on, and my young son was not tall enough to do so. I figured whatever was in our house must have thought we needed the heat on because of what I had said the night before.

Several months passed and things were fairly calm, with the exception of the feeling of a male presence watching us at times, which we were getting used to at this point. One afternoon I had been working on finishing some laundry. Our washer and dryer were located in the basement area directly adjacent to the steps that led down from the kitchen. I had just been in the basement a few minutes earlier collecting a load of wash from the dryer. I was upstairs folding the laundry when I heard the distinct sound of running water. I followed the sound out to the kitchen and could tell that it was coming from the basement. I decided to investigate and descended down the steps. As I did, I noticed steam billowing up from the washbasin. As I approached the basin, I could see that the hot water was gushing from the faucet. I immediately turned it off, which took two to three full turns of the handle, and looked around the basement to see if anyone was down

there. I was quite alone, but I still had an odd feeling of something present with me in that basement. Only five minutes earlier I had walked right past this very spot and would have undoubtedly noticed something as obvious as this. Other things happened with my plumbing as well. In the kitchen fairly regularly, the drainpipes below my sink would be found unscrewed and leaking. Sometimes I would tighten them up one day only to find them loose and unscrewed the next.

During the evenings, I usually like to sit down in front of the television like most Americans and relax while watching a good show. Many times over the course of the years I did just that in this home, often while I waited for my wife to return home from work or after putting my then baby son to bed for the evening. Several times the spirit joined me as well. Usually, I would be sitting in a chair or lying on the couch and suddenly would feel a very strong presence directly behind me, most often from the dining room area. I don't really know how to explain this part, but the presence I felt was definitely an older male entity. Never in all the years I was there did I see an apparition of this man. I was not scared of him; however, when this took place it became quite annoying. Usually, I would find myself talking to him like there was actually some other living person standing with me in the room. I would very strongly suggest he go elsewhere. More often than not he wouldn't leave. I would either put up with the staring or go to bed. Sometimes after I went to bed, he would stand in the doorway of my bedroom. One night after going to bed, I found my wife already asleep. The presence seemed to have followed me to the bedroom and stood in the doorway watching me while I lay in bed. It took me at least two hours to get to sleep. Once during the episode, I actually heard the floor creak as if a person were standing there.

The next morning while eating breakfast with my wife, she asked me if I had heard the creaking sound in the doorway the night before. I told her yes and asked her why she was asking. My wife explained to me that she, too, had been unable to sleep the night before because she could feel our ghostly guest staring at her from the doorway.

On another evening while lying in bed, I felt a very strong presence in my bedroom. As I lay awake, I noticed movement out of the corner of my eye. I remember closing my eyes, thinking that maybe I was actually asleep and just half dreaming. I again opened them and came to realize that I was not dreaming. Floating across the bedroom in the dim light was a small ball of light about the size of a half dollar. It moved over my bed and toward our window. I tried waking my wife, but she was sound asleep. It continued to

move away from me, and then all at once, it slowly dissolved away through my window. It took me hours to fall asleep after that experience.

Over the six years that we lived there, some of the things I described happened several times over. My wife and I always felt that we were not alone. We always felt an odd feeling when we were in specific areas of the house. The living room, basement, dining room and hallway between the bedrooms were the sensitive areas. The entire house had a very charged feeling to it, but in a good way. The presence was there all the time, but it seemed most of the time to be a friendly, comforting one.

In January 1999, my wife and I decided to buy a larger home in the Weston, Wisconsin area for our growing family. Prior to moving out, I was speaking to my neighbor, who had lived next door to our house since the early 1930s. I explained to her for the first time some of the paranormal experiences that we had while living in our home. To my surprise, my neighbor's facial expression changed as if she herself had seen a ghost. My neighbor began to explain to me that one of the prior owners, who had lived there for some forty years, died of old age right in our living room in 1987. Evidently, no one found him until about three days later. Maybe this was one of the spirits in my home still attached to the house, not realizing that he had passed on. This would possibly explain the strong presence in the living room and dining room areas. My neighbor also told me that the original builder of the house died of a heart attack right in the hallway between our bedrooms in the mid-1950s. She knew this because she and her father went over to the house when her neighbor had collapsed on the floor to try to help. She said the man literally died in her father's arms right there in that hallway. Is this the spirit that stood in my doorway at night? Does he realize that he has departed this earth? Maybe he doesn't wish to leave the house he built. I guess I may never know. One thing is for certain: I know that anyone who lives in the house, which I spent six years in, will most definitely have an extra set of watchful eyes keeping tabs on him or her. I hope they find the presence helpful and as interesting as my family did.

Philanthropic Spirit

On the corner of McIndoe and Fourth Streets sits the home of one of Wausau's most prominent families, the Yawkeys. Cyrus Carpenter Yawkey was born in Chicago in 1862. He spent the majority of his childhood in

Above, left: Cyrus Carpenter Yawkey. *Courtesy of the Marathon County Historical Society.*

Above, right: Alice Maude Richardson Yawkey. *Courtesy of the Marathon County Historical Society.*

Michigan, which is where he met and married Alice Maude Richardson in the autumn of 1887. The couple celebrated the birth of their only child, Leigh, in August 1888. During that same year, the Yawkeys left Michigan for Wisconsin, where the Yawkey & Lee Lumber Company was soon formed. The area the Yawkeys settled, about sixty miles north of Wausau, had an abundance of hazelnut trees, inspiring Mrs. Yawkey to name the town Hazelhurst.

In 1899, the Yawkeys moved to Wausau, where they built their lavish Classical Revival home in 1900–1. The home was reportedly the most expensive house in town at that time, at $35,000, and was built using wood from the Yawkeys' own mill. The house boasted a red Italian marble fireplace, painted canvas ceiling squares in the dining room and a ladies' parlor, where guests of Mrs. Yawkey would await her entrance.

Shortly after the home was built, in 1908, the Yawkeys hired George Maher to remodel the house and build an addition to the second story. It was at that time that the home's sun porch was built. In 1911, a stunning formal garden was added to the grounds adjacent the sun porch. It was designed by landscape architects Morell and Nichols to resemble an English garden, complete with a pond and pergola. The garden changed colors throughout the growing season, with a different plant always in bloom.

Mr. Yawkey made his mark on Wausau not only through his lumber mill but also by leading the Wausau Group, an organization of prominent lumbermen who, sensing the decline of the industry around the turn of the century, resolved to remain in the area and pursue other types of business. Over the course of his lifetime, Mr. Yawkey held high-ranking positions with Northwestern Life Insurance Company, Marathon Paper Mills, Wisconsin Valley Electric Company, Wausau Paper Mills and the American National Bank of Wausau, as well as others. He also served as a colonel in the Wisconsin State Guard during World War I.

The Yawkeys were full of civic pride and donated both money and land to build parks in the area, including Marathon and Riverside Parks. Yawkey Park, located across the street from their home, behind the YMCA, was donated to the City of Wausau by the Yawkeys in October 1920. The park's original fountain and bronze statue remain.

Cyrus Yawkey passed away on May 18, 1943, at the age of eighty. Mrs. Yawkey continued to live in the house until she died in 1953. In 1954, following her mother's death, Leigh Yawkey Woodson donated the home to the Marathon County Historical Society to be used as a museum. The Yawkeys are buried in Wausau's Pine Grove Cemetery.

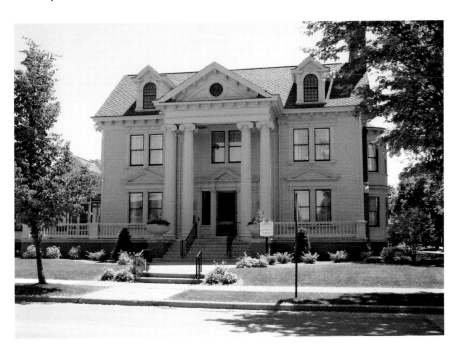

The Yawkey House Museum.

In 1974, the Yawkey House was added to the National Register of Historic Places. In 2008, the house was restored to the way it had looked in 1908, after George Maher's remodel. During the restoration, thirteen layers of paint were removed, and the home was brought back to its original beige color.

Some believe that the Yawkeys have remained in their beloved home since their deaths. Over the years, people have reported strong feelings of a presence throughout the home. The smell of smoke from a pipe, like that which Mr. Yawkey enjoyed, is sometimes found lingering near the first-floor staircase landing. A book of poetry, thought to be a favorite of Mrs. Yawkey's, is reported to move about the museum, showing up in different areas.

In 2004, a museum curator opened the house one morning to find a picture taken off the wall and lying unbroken on the floor in the den where Mr. Yawkey passed away. Next to the picture were two glasses and a water pitcher. There had been no one in the museum overnight, and nothing else was askew.

An employee working alone in the basement of the Yawkey House heard his name called behind him one afternoon. He immediately left the basement, but when he got to the top of the stairs, the door slammed shut in front of him. He searched the museum and found that there was no one else in the building.

While enjoying a break in the old servants' kitchen, a group of museum employees were discussing the Yawkey family when they witnessed a cap from a soda bottle slide quickly across a break room table and onto the floor without being touched.

One of the most unusual incidents at the Yawkey House involves the museum's snow removal company. According to reports, the company's equipment often fails inexplicably when workers are clearing the front walks of the museum, leaving them to shovel the sidewalk by hand. Perhaps Mr. Yawkey prefers to see a job done with good old-fashioned elbow grease.

FINAL CALL

Across the street from the Yawkey mansion sits the home of the Yawkeys' daughter and son-in-law. Leigh Yawkey married Aytchmonde Perrin Woodson in front of 250 guests at the First Universalist Church of Wausau on August 15, 1911. The extravagant wedding was decorated with an oak leaf theme. The reception, decorated with white lilies, was held at the Yawkey home. Mrs. Yawkey was the matron of honor.

The first two years of the Woodsons' marriage was spent in Kansas City, where Mr. Woodson practiced law. In 1913, Cyrus Yawkey offered Mr. Woodson a position in the Wausau Group. The offer was accepted, and the Woodsons moved back to Wausau.

Generously, Mr. and Mrs. Yawkey hired architect George Maher to build a house for their daughter and son-in-law. Wanting to have their family close, the Yawkeys purchased the house across the street and had it moved so the Woodsons' home could be built there.

The brick house was designed in the Prairie School style, with a hipped tile roof and ribbon windows. It boasts several arches and an intricately carved walnut staircase. A large stained-glass window, located at the top of the staircase, was removed in 1962 but replaced in 2006. A lotus flower motif adorns both the inside of the house and the exterior.

The Woodsons moved into their new home in 1914 and welcomed their first child and only son, Cyrus Yawkey Woodson, into the world on September 8 of that same year. In 1917, their daughter Nancy was born, followed by Alice in 1918 and Margaret in 1920.

Mr. Woodson was a successful businessman, holding high-ranking positions within eighty-eight different companies over the course of his career. He also started a charitable foundation, the Aytchmonde Woodson Foundation Inc., which helped aid local charities and schools. He, along with Mrs. Woodson, helped to develop the Woodson YMCA.

Mrs. Woodson was an active philanthropist, belonging to many local organizations. She was president of the Aytchmonde Woodson Foundation, Inc., and was on the board of directors of Wausau Memorial Hospital.

Tragedy struck the Woodson family during a New Year's party on January 1, 1934, when young Cyrus Yawkey Woodson took his own life with a pistol in an upstairs room of the home. According to reports, he had received a telephone call from an unknown caller immediately prior to his death. He was only nineteen years old.

Mr. Woodson passed away on October 8, 1958, at seventy-seven years of age. Mrs. Woodson passed away on January 18, 1963, at the age of seventy-four. The Woodsons are buried in Wausau's Pine Grove Cemetery.

The Immanuel Baptist Church purchased the Woodson house in 1954 and built a sanctuary on the side of it in 1963. The church sold the house to the Marathon County Historical Society in 1995. It is currently the Woodson History Center, housing historical documents, books, artifacts and administrative offices.

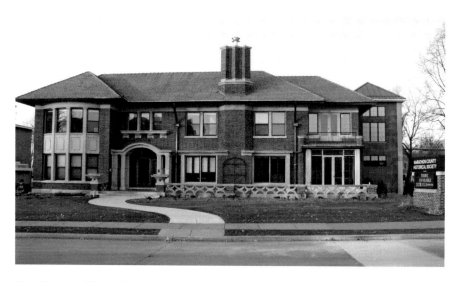

The Woodson History Center, home to the Marathon County Historical Society.

Over the past fifty years, many strange occurrences have been reported within the walls of the Woodson house. Footfalls can be heard on the second-floor hallway when no one else is around. Phantom footsteps have been heard coming down the first-floor staircase, with no plausible explanation. In a hallway that leads to the church sanctuary, people have witnessed the ghostly apparition of a young man. These supernatural encounters make one wonder if young Mr. Woodson has remained in the home where he lived out his fleeting life.

Perhaps the most mysterious phenomenon in the Woodson home is the report of employees hearing a telephone ring in an upstairs balcony room. When the door to the room is opened, the ringing abruptly stops. The room does not contain a telephone and hasn't for years.

A Little Child Shall Lead Them

In February 2006, the WPRS completed an investigation of a private residence in the city of Waupaca, Wisconsin. The Harris family had been experiencing what they considered paranormal activity since moving into the one-hundred-plus-year-old home, and they were, quite frankly, creeped

out by it. The Harris family was a young couple with two small children and one dog, but their home held more than a fledgling family.

Bath time for children can be heaven or hell, depending upon each child's possible aversion to soap and water, so Mrs. Harris tried to make bath time a joyous occasion for her children. Bubble bath liquids in ample supply joined warm, fluffy bath towels in an effort to relax the children. A container of crayons sat on the bathtub ledge to awaken the curious imaginations of her bathing progeny. And awaken curious imaginations it did! One day upon hearing a clamor in the bathroom, Mrs. Harris went to check on her children and noted that the crayon container was lying inside the bathtub and the crayons were lying on the floor outside the bathtub. Wondering where her children were, she entered the room to pick up the mess and gasped! Sitting at the far end of the bathtub was the apparition of a small child who, in his own surprise, disappeared from view.

The child apparition was not the only non-family member in the home. Mr. Harris saw a woman in white standing in front of the master bedroom closet; she told him her name was Charlene. And Mrs. Harris witnessed the face of a man peering into the middle panel of a nine-window-paned kitchen door in the dark of night, only to find that there was no body attached to the face. Their oldest child, a toddler at the time, would hold conversations with unseen entities, and he would say "hello" and "goodbye" when entering and leaving empty rooms.

Perhaps the most frightening instance for Mrs. Harris occurred one night when she was sleeping peacefully and felt someone crawling up on the end of her bed. Half awake, she sat up and reached for her son, but no one was there. She then jumped from her bed and opened her door to check the hallway and her son's room—no one was in the hallway and his door remained closed. Perhaps this was the child apparition searching for some loving maternal human contact.

The family also reported strange occurrences such as the dog staring behind the couch when no one was there, unexplainable electrical malfunctions, hearing disembodied voices and whispers and finding multiple orbs in family photographs, among other things. But during the February 2006 investigation, the WPRS was unable to collect any evidence or even gain a suspicion that anything paranormal was occurring. But, as is noted in the investigative report, this could be the result of the children being the catalysts for much activity, and they were not present during the first investigation.

A second investigation occurred in June 2006 with some striking results. Several pictures were taken of the family in both digital format and 35mm

film, and many of the family pictures contained misty orbs. Photos were taken of the crawl space underneath the home in which a peculiar mist was evident that could not be explained as being smoke or fog. The vaporous mist disappeared in consecutive shots taken seconds later, and as hard as they tried, investigators could not re-create the mist. Mr. Harris later informed the investigators that he had found an antique child's sleigh in the same area where the mist was photographed in the crawl space.

Most intriguing of the June 2006 investigation was video footage of the family's young son as he attempted to fall asleep. With parental permission, an infrared video camera and a Tri-field meter were set up in their son's bedroom, and his nightly ritual was captured. Upon reviewing the video, the young boy can be seen drifting off to sleep. But he quickly sits up, looks toward his bedroom door and asks, "What?" He then hides his face on the bed for a moment and sits up a second time to look at the door. At this point the Tri-field meter—a loud screeching, irritant—sounds, varying from low to high and then back again.

The child again lies down, rocks from side to side, covers his ears with his hands and looks toward the door. He then shifts around, stands up and says, "Not ready, not ready, not ready." While he speaks, he is holding his hands out toward something in the room. He lies down again and pulls the covers over his head, stating three or four times that he is a ghost. Suddenly the child stands up next to his bed with the covers still over his head and says three or four times, "I see it." Just as quickly and unexpectedly as the previous occurrences, the child lies down on his bed and falls asleep.

While reviewing the video footage, investigators noted that after the child falls asleep the faint sound of a train whistle can be heard in the background. Seconds later, an orb shoots from the right side of the screen moving toward the child at a high rate of speed. Mid-flight, the orb temporarily changes direction and then flies straight toward the child's head and disappears from view. The orb is never again seen in the room during this filming.

There are several theories that have been proposed regarding whether children have an innate ability to see ghosts. For example, some theorize that young children are more attuned to the paranormal than adults because they are closer to the origin of birth and are, therefore, closer to the thin veil between life and non-life. Or, possibly, children have not yet been taught to ignore the paranormal because adults have not had the chance to dissuade them from believing in what they see. Theories may never be proven, but in this home researchers were led by a child to possible paranormal activities. Would you like to come out and play?

Bat-Man of the North Woods

In Oneida County, sixty miles north of Wausau, sits the city of Rhinelander. When most Wisconsinites think of Rhinelander, the mythical creature the Hodag comes to mind. The Hodag, contrived by pioneer Eugene Shepard in the 1890s, is a large, green, lizard-like creature covered with horns. Over the years, the eight thousand residents of Rhinelander have embraced the Hodag as the symbol of their city. It may surprise them to learn that the Hodag isn't the only unusual creature that calls the north woods of Rhinelander its stomping ground.

In the spring of 2004, the WPRS was contacted by the Bishops. They had been experiencing odd activity on their Rhinelander property for almost fifty years. The three-acre property had a house, barn and outbuildings all built in 1906 and had been owned by the Bishop family since the 1950s.

Since the very beginning of their occupancy, the Bishops and their friends experienced strong feelings of a supernatural presence in the house. Shadows were seen out of the corner of the eye. Lights turned on and off by themselves. Doors were opened and closed by someone unseen. Pots and pans could be heard rattling about inside the cupboards when no family member was in the kitchen.

After some time passed, the activity seemed to intensify, and the family began seeing full-body apparitions. A male entity wearing a hat was seen many times throughout the home. A tall, gaunt man with a beard was seen walking from an upstairs bathroom all the way down to the basement.

One upstairs bedroom in particular seemed to be very active. The Bishops' daughter was trying to sleep one night when she heard a female voice humming a song. The child asked the spirit to stop, and the humming immediately ceased. When the family was downstairs below the bedroom, they routinely heard the sound of footsteps walking above them and a sound that resembled a marble being rolled across the floor.

The ghostly activity in the house, however, was nothing compared to the property's barn. The barn housed a presence so formidable that family members agreed it must be pure evil. Friends refused to enter the barn altogether.

The Bishops' young son, when out in the yard, would often see a shadow pass by the inside of the barn's second-story window when no one was there. When he stepped into the barn to investigate, he found the air frigid, and the hair on his arms and legs would stand on end. This occurred many times, into his adulthood.

An anomalous light (upper left) in a reportedly haunted Rhinelander barn.

Perhaps the most disturbing report from this Rhinelander home comes from the early 1970s. A friend of Mr. and Mrs. Bishop was in the yard behind the barn when she was startled by a large beast that she described as half human, half bat. This very same creature was witnessed by two family members shortly thereafter. This time it was standing on the front porch of the home. Coming face to face with this bat-man would be enough to frighten even a Hodag away.

STRANDED IN SUGAR CAMP

The original inhabitants of this area located in Oneida County, Wisconsin, were a band of about 150 Lac du Flambeau Indians who used the place as a spring and summer camp. They spent the fair-weather months gathering wild rice, fishing and hunting, and during the spring they would gather the sap from the large growths of sugar maple trees and process it into maple syrup and sugar. Upon entrance of the logging industry, the area was called Robbins, named after the owner of the narrow-gauge railroad built for lumbering use.

Euro-Americans who came to purchase the maple syrup and sugar from the Lac du Flambeau called the native settlement "the sugar camp," and

when the town was newly settled in the late 1890s by those same customers, it was renamed Sugar Camp.

An area of natural beauty and bountiful wildlife, one would hardly imagine that it is also inhabited by the spirits of its restless ancestors. Imagine living in a home with no relief from paranormal activities for fourteen years! One Sugar Camp family did just that before contacting the WPRS to initially request information and later an investigation. The Johnson family first contacted the WPRS in October 2006. The family wanted information only and took a WPRS investigator's advice to start keeping a detailed log of all the activity as it was occurring. After several months, the family requested that the WPRS come in and investigate the dwelling.

The Johnson family purchased their Sugar Camp home in the early 1980s and, from the start, experienced various odd phenomena. Family members recounted incidents such as a mattress being violently moved or shaken while a young girl slept upon it and a young boy seeing a solid orb with a swirling white misty center floating above the bed where he lay. Not only did the children witness such strange occurrences, but Mrs. Johnson also heard a small child call out her name and the word "Mom." There was no one else in the home at the time.

There had always been feelings of a presence in the home, and on at least one occasion, the son had a strong feeling that he was being watched by an unseen presence while showering. Separate family members have also heard footsteps in various areas of the home that could not be accounted for by any live presence—heavy-booted, male footsteps tromping down the hall and lighter, high-heeled female tapping in the kitchen. On one unsettling occasion, a guest couple was awakened from sleep by loud, stomping footfalls in the northeast bedroom, but when they turned on the light in the room, no one was there. The northeast bedroom was also known to be inexplicably cold, and it was later noted by a sensitive to house the sad presence of an elderly couple who seemed to be waiting for their son. When asked to leave the home, the elderly woman would become very angry—a logical reaction for a mother awaiting the return of her child.

At the request of the family, the WPRS completed an investigation of the home in February 2007. While no concrete evidence was obtained that pointed to the paranormal, there were two anomalous EMF Trifield readings noted in the home that, once stabilized, could not be re-created by investigators. Such readings are sometimes noted during the presence of paranormal energies. The most unusual moment of the investigation occurred while investigators were conducting an EVP session in the northeast

bedroom—the cold bedroom—as all investigators present heard a short, childlike sigh. The investigators shivered momentarily and froze. Peering at one another through the room, they all acknowledged hearing the audible sigh, but later it could not be found on audiotape.

During the last WPRS contact with the Johnson family, they acknowledged that they continue to experience various strange activities in the home. Who or what could this be? A sad, elderly couple eternally waiting for their son; perhaps a lonely boy endlessly searching for his parents and sighing in exasperation; quite possibly, the spirit ancestors of the original sugar camp inhabitants demanding the return of their sacred Mother Earth.

An old folktale states that during the warming days of spring, while traveling past the maple groves of northern Wisconsin, one can look through the trees and see images of ancient gatherers tapping the rising syrup of wakening maple trees. As a token of friendship and peace, may we suggest that the Johnson family set out a few sugar maple leaves, organic or candy, for their invisible guests? Such a gift may appease both the ancient and child spirits that continue to roam the home.

HISTORICAL GHOSTS OF GILLETT

The Gillett Area Historical Society (GAHS) building is a home built in 1908 by Walter and Ruth Smith on the actual foundation of the first home that was built in the town of Gillett, Wisconsin. The first home was built by Rodney and Mary Gillett in 1868 and sold to attorney Benjamin Goldberg and his wife in 1906. After much controversy and probable illegal activities, the Goldberg home burned to the ground in 1908 and was a total loss.

There is much speculation that Benjamin Goldberg started the fire that destroyed his home to obtain insurance money, and it is alleged that he buried many of the home's belongings in the backyard prior to setting fire to the building. After the fire, Benjamin Goldberg sold the lot to the Smiths, who then rebuilt the Gillett home using the original floor plans. From the day the Smiths rebuilt the home, a member of the Smith family had resided in or owned the building until 2006, when the home was sold to a non-family member. The young couple that bought the home lived in it for about two years before selling the home to the GAHS.

The last family containing a Smith descendant who resided in the home before its sale to a non-family member witnessed many paranormal activities,

Early photograph of the Smith house, now the Gillett Area Historical Society. *Courtesy of the Smith family.*

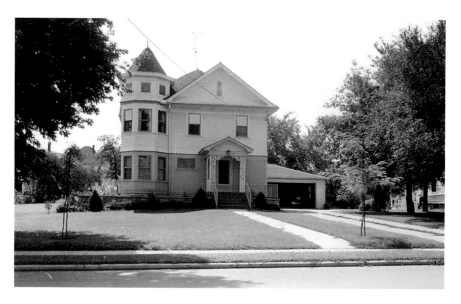

The Gillett Area Historical Society, circa 1930. *Courtesy of the Smith family.*

as had previous Smith family members. The home has long been rumored by Gillett town residents to be haunted. This is no surprise, as it seems to have been a hotbed of unexplainable activities through its one-hundred-plus-year existence. Any building over one hundred years old is bound to have its share of skeletons in the closets.

The final Smith family descendants to own the home bought it in 1994 and immediately began refurbishing the old house. All of the minor construction activity may have unleashed the spirits of the home, for the family began experiencing strange activities as soon as they began work on the building. Family members often heard voices in the home when no one was nearby, and on several occasions Jane, the mother, heard someone call out her name when no one else was in the home.

After moving into the home, Jane and her husband were asleep in the master bedroom one night when they were instantly awakened at 12:01 a.m. by a large crash. The crash sounded like a large pane of glass had fallen and shattered next to the bed, but when the couple jumped out of bed to check the damages, there was no broken glass. Next, they searched the entire home looking for the cause and damage but never found a thing.

Much activity seemed to center around Jane's son, Andy, the only direct Smith family descendant in the home. He would often not sleep well in his assigned bedroom, and he started sleeping with his radio on all through the

night. He begged for the radio and said it was to drown out the voices of the people whispering in his ear at night. On one particularly unnerving day, Andy had a friend to his home, and as they were leaving the second-floor bedroom to go outside, Andy found a single acorn lying on the floor. He picked up the acorn, wondering where it came from, and tossed it lightly on his bed before turning to run down the stairs. But they had forgotten something in the bedroom and turned back to the room, at which point they both saw a pyramid of acorns perched on the bed in the exact place Andy had tossed the first lonely acorn. From that point on, Andy's friend refused to come into the home.

The spirits in the home did not appear to be malevolent, as can be noted in a tender incident involving Jane's daughter, Hannah. Hannah was a mere infant at the time, asleep in her crib while her parents were asleep in their bedroom. Jane's husband was unexpectedly awakened in the middle of the night by someone touching his arm and telling him to check on Hannah. Thinking Jane had made the request, he got up and walked into the infant's room to check on her. He immediately noticed that she had stopped breathing and was turning blue. He walked in just in time to save her life and was later dumbfounded when Jane told him that she had not woken him; she'd been fast asleep.

Though Jane's husband did not believe in the paranormal, he had a chilling incident a few years later in the home that made him reconsider. He had woken up one morning and gone down the stairs to start coffee in the kitchen. As he stepped off the stairs and walked toward the dining room, he saw an elderly woman in a dark dress move from the dining room into the kitchen. He immediately called to the intruder and followed her into the kitchen, only to find that no one was there. He searched through the entire home and never found the woman. Though the incident nagged at him, he never told Jane about it until after the following event. Sometime later, the family was visiting the home of a distant relative when Jane's husband saw a family portrait of Rodney and Mary Gillett with several of their grown children; the female intruder was staring back at him from the picture frame—it was Mary Gillett!

The WPRS was invited to investigate the GAHS and did so on May 1, 2010. For a portion of the investigation, Jane and her two children, Andy and Hannah, were in attendance, mainly for informative reasons and to serve as trigger objects. While no conclusive evidence was garnered during the investigation, it was noted that several intriguing incidents did occur that may or may not have been paranormal in nature.

For example, during the period of time that Andy was involved in an EVP session in his former bedroom, his phone was in the kitchen and turned off. After the EVP session, Andy noted a voicemail from a friend who questioned why Andy had called him. Andy hadn't called him at the time in question, as he was in the EVP session and his phone was turned off and not in his possession. It should be noted that this particular friend had been in attendance during the unusual acorn pyramid incident in teen Andy's bedroom, after which this friend would no longer come into the home. The friend still refuses to enter the building as a full-grown adult.

After later studying the available audio, video and digital images from the investigation, only one anomaly was found. The EVP session conducted in Andy's bedroom resulted in one strong EVP that, after careful consideration and checking for possible audio contamination, has been accepted as a possible entity contact. During the EVP session, Andy states, "If you'd please come forward and talk to us for a while we'd love to talk to you too," to which there seems to be an audible reply several seconds later that sounds like "no" or possibly "go."

Can we say for certain that the Gillett Area Historical Society is haunted? No; we can't say anything for certain. But there is enough accumulated evidence that strongly suggests that the building is housing more than just antiques. Don't believe us? Go and visit it for yourself. Just don't blame us if you run into Mary Gillett in the dining room. She's probably just setting the table for Sunday dinner.

MOSINEE POLTERGEIST

Fifteen miles south of Wausau is the city originally known as Little Bull Falls. The city got its start in 1836, when the first sawmill in the area was opened. Other businesses were quick to follow, including a blacksmith shop, grocer and saloon.

Just over twenty years later, the city was well established. A post office was opened in July 1857, and at that time the city's name was changed from Little Bull Falls to Mosinee. It is believed to be named after a Menominee Indian chief who was well respected in the area.

In the summer of 2002, the WPRS was contacted by the Saylor family, whose home was teeming with paranormal activity. The Saylors had been living in the house since the spring of 1999 and had been having encounters

with the unknown since a few months after moving in. The house had been built in 1916, and an addition was built in 1982. While researching the history of the house, Mrs. Saylor discovered that two gentlemen had passed away there, one in 1979 and the other in 1990.

The paranormal activity began one evening about six months after the family moved into the home, when the couple was startled awake by the sound of their kitchen cupboards being slammed shut. Upon investigation, the cabinets were still and nothing seemed to be out of place in the kitchen. Other unusual noises have been experienced in the house, including a woman's laughter and the sound of music and singing when no one else is around.

After some time, the spirits in this Mosinee home began to make themselves known in more concrete ways. Both the hot and cold faucets in the bathroom would turn on by themselves. The television would turn on without the aid of living hands. The basement light frequently turned on by itself after Mr. Saylor turned it off.

Several times over the course of the three years that the Saylors had lived in the home, they would leave the house, lock the door and return to find that the front door had been unlocked. Sometimes, the door would be found wide open. After a look around, it was always determined that nothing had been stolen or disturbed.

The family's dog began to act strangely in the middle of the night. He would back away from the kitchen door, growling and barking at something unseen. Interestingly, this is the same area where Mrs. Saylor often felt as if she were being watched by what she described as a male presence. During a 2002 investigation, a WPRS investigator also experienced this strong feeling of a presence.

Later, during the same investigation, strange knocking and thumps were heard, often in response to investigators' questions. It seems that this noisy spirit was pleased to finally be getting the attention he had been seeking.

Coloma Shadow Person

Seventy miles south of Wausau, with a population just shy of five hundred, you will find the village of Coloma. In the spring of 2008, the WPRS was contacted for help by a Coloma family that was experiencing almost daily paranormal activity in their home. The activity was witnessed by all family members, as well as many of their friends.

The Collins family had purchased the home only a few months earlier, after the untimely death of a family member who had lived there before she passed away. Mr. and Mrs. Collins felt certain that the activity they were experiencing was due to their deceased loved one trying to get a message to them.

All members of the Collins family reported seeing a black shadow person on the wall of the home's family room. They also frequently caught movement out of the corners of their eyes throughout the house and felt as if they were being watched. Mr. and Mrs. Collins were often suddenly awakened in the middle of the night by the feeling of a strong presence watching them from the doorway of the master bedroom.

The family was plagued by experiences that are very common in cases of paranormal activity, such as electronic equipment turning on and off by itself, small items being moved from their original place and found elsewhere and pictures turned face-down on tables. They often heard sounds in the kitchen, such as the clanking of pots and pans and cupboards opening, only to find that no one was in the room and nothing was out of order.

Both the eldest son and eldest daughter witnessed a softball-sized orb of light on the stairwell leading to the home's family room. The youngest daughter claimed to talk and play with someone unseen whom she described as a "friendly woman." All members of the Collins family have reported being touched or lightly brushed by unseen hands.

Mr. Collins decided to contact the WPRS after he witnessed the full-body apparition of the deceased family member. She was standing in the front yard of the home, looking into the front window. She was dressed in the same motorcycle jacket and blue jeans that she had been buried in.

While the WPRS is often able to find a non-paranormal cause for a client's experiences, investigators were surprised at what they discovered in Coloma. All four investigators that evening experienced the soft touch of unseen hands that the Collins family had described. It felt as if they were being lightly brushed on the hands and face, almost as if cobwebs were being draped over them. The WPRS did a thorough search for cobwebs or spider webs, but there were none. The touching happened both in the basement of the home and in the master bedroom.

Also in the master bedroom, one investigator witnessed what he described as a band of light moving across the door. Several experiments were performed to try to re-create the light, but to no avail.

After going through the evidence, investigators found that multiple EVPs were captured. In the master bedroom, in response to the question, "Is there

Possible apparition captured on film in Coloma, Wisconsin. *Courtesy of James Coscio.*

anyone here who would like to speak with us?" a female voice whispering, "Hello?" was captured. The WPRS also captured a female voice, perhaps the same one, stating, "I touched your hand."

More EVPs were obtained in the family room. The first was a whispered, "Do it," and the second was a resounding, "Sigh."

Perhaps the most compelling evidence of a haunting in this Coloma home was a photograph taken in the kitchen, facing toward the doorway to the dining room. The photograph revealed a black silhouette of a woman leaning against the door frame. She appears to be wearing a motorcycle jacket.

It's in the Blood

The Shaw family of Abbotsford, Wisconsin, knows a thing or two about hauntings, for their family has had paranormal experiences going back at least five generations. Many of the experiences have occurred in their late nineteenth-century home, but many have occurred outside of this residence. As a matter of fact, the Shaws believe that they may have an inherited ability to see ghosts.

Current studies in cellular memory suggest that donated organs may carry electromagnetic charges of their former owner, the dearly departed, and can exchange these charges with the host environment, the organ recipient, resulting in a possible transfer of the original owner's personality and traits to the donor recipient. This writer has an aunt who received several transplanted organs and, after recuperation, started having cravings for certain foods from a particular fast-food chain. This struck her as bizarre, because she didn't eat fast food and never craved this particular food item prior to her transplants. Once she gave into her cravings for this food, she found that the desire for it was reduced to a controllable level. A few years after her surgery, she found out that her organs had been donated from a young male who was a fast-food junkie. There are innumerable studies to be found regarding such relatively recent phenomena.

Another example of cellular memory at work in our daily lives may be found in the paranormal. A recent paranormal theory, memory possession, has emerged that suggests that seeing a ghost or experiencing a haunting may be associated more with our genes than with our heads. For example, if an individual experiences a residual haunting involving a murder or suicide, he or she will sometimes experience the feelings, emotions and physical pain associated with the initial incident. Cellular memory theories suggest by extrapolation that our ancestors' personalities, traits and memories may be stored in our own DNA and could electromagnetically stimulate a current-day experience and reaction to an incident that occurred to an ancestor many, many years ago. Is such a genetic link to our ancestors a possible explanation for an inherited family ability to perceive the paranormal?

The grandparents of the current Shaw residents bought the home in 1957 and immediately started experiencing the unexplainable. Their home was a vessel for ghostly noises and object disappearances, but they also had spectral visitors that were seen by family, friends and neighbors. Separate family members have reported seeing the apparition of a tall, thin man wearing a top hat over the years, and one former occupant of the home had a feeling of being hugged by an unseen hugger several times.

Paranormal activities began in earnest in 1980 during a renovation of the upstairs area of the home and have continued unabated to this day. Sounds of a baby crying in an upstairs bedroom can be heard in the bottom-floor living room, but when the baby is checked in its crib it is sound asleep. Then, after returning to the living room, the crying resumes, and a second check again reveals a sleeping baby. Sounds of footsteps are also heard on the second-floor hallway and on the stairwell when no one is on that floor. And a

family member once saw the apparition of a woman standing in an upstairs doorway tapping a wooden spoon in her hand and saying, "You are in so much trouble!" Perhaps this is Grandma Shaw chastising from the grave?

Last, but not least disturbing, are the subterranean specters. A Shaw daughter reported seeing the apparition of a young girl with short, dark hair and wearing a blue dress in the home's basement. Later, in April 2004, several witnesses outside the home observed a bright white light emanating from the north basement window of the residence. They then saw a human figure pass between the light and the window several times, casting an eerie pall across the windowpane, until the light slowly faded and was completely extinguished within two minutes. There was no one in the home at the time.

There are reports that a previous owner of the home, a non-Shaw, committed suicide in the 1940s by hanging himself inside the home. Where did he hang himself—possibly an upstairs or basement rafter? The death could not be confirmed as having been the result of a suicide, but it has been confirmed that an owner of the home died within the house during the 1940s. Could this be the man in the top hat or the basement specter? Perhaps it is Grandpa Shaw, who added the basement to the home in the late 1950s, coming back to check on his work.

Does the Shaw family have an inherited ability to see ghosts? And, if so, are the ghosts in their home family or non-family? When it comes down to a haunting, does it really matter?

WAUSAU'S HAUNTED MANSION

Wausau today is a moderately sized city. Each year, as it grows in size, more modern structures are added. But at one time, Wausau was a much smaller place filled with some elegant homes built by the lumber, steel and railroad industrialists who helped develop the city into what it is today. Many of these homes still exist, restored to their former glory. Some of these structures still possess remnants of their previous owners that wish to stay on in the hereafter, maybe because of unfinished business, earthly personal attachments or simply because they do not realize they have died. This is a true account of one of those prominent former families.

Daniel Longfellow Plumer was born on July 3, 1837, in Epping, Rockingham County, New Hampshire, and settled in Wausau in 1857. He began his career in lumbering and continued this until about 1890. In

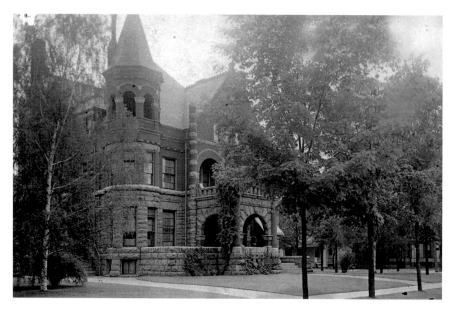

The Plumer mansion in its glory days. *Courtesy of the Marathon County Historical Society.*

1867, he became involved in the brokerage business and founded what is today the M&I First American Bank. He served in a political sense as village of Wausau supervisor, state assembly member, three terms as mayor of Wausau, county surveyor and on the Board of Regents of the University of Wisconsin. In 1869, he married Mary Jane Draper. The Plumers had one son who died during infancy. Daniel Plumber died November 20, 1920, and his wife followed him in death in 1928.

Daniel Plumer built his mansion in 1890, and it symbolized one of Wausau's finest examples of architecture at that time. Its castle-like gothic features with native granite walls and massive porches made for a stunning sight. After the deaths of Mr. and Mrs. Plumer, the mansion was donated to the Memorial Hospital and used by the hospital for a number of years. Around World War II, the *Milwaukee Journal* moved into the building. In 1954, newly established WSAU Channel 7 television set up its studio in the mansion. Around 1972, WSAU moved to a new location on Grand Avenue, where it continues as WSAW today. Sadly, that same year the building was razed.

It was during the summer of 1967 that an employee who was a maintenance worker at the Channel 7 television studio was reporting to work

Above, left: Daniel Longfellow Plumer. *Courtesy of the Marathon County Historical Society.*

Above, right: Mary Jane Draper Plumer. *Courtesy of the Marathon County Historical Society.*

for the day. He arrived in the morning as usual and was busy completing his daily tasks of mopping and waxing floors. While he was waxing the first-floor studio of the mansion, he noticed a woman in a light blue dress with lacy sleeves materialize through a wall on one side of the room. The dress she was wearing appeared to be from the Victorian era. The woman did not appear to notice the employee as she glided about six inches above the floor and moved past him, staring straight ahead and missing him by mere feet. As she passed by, a very cold breeze was felt against his skin. The specter continued on through the room and disappeared right through a wall on the opposite end of the room. Moments later, a co-worker from the studio walked into the room and asked who the lady was that had come into the room ahead of him. The maintenance worker was speechless. The lady he had seen appeared to be very solid in form, but he knew he had seen a ghost.

A few weeks later, the same employee was moving some cleaning equipment to his work site. A large piece of equipment fell on him, causing injury. The following day, he checked into Memorial Hospital for care. While he was being wheeled down a main hallway to surgery, something caught his attention. He saw a life-sized portrait of the woman he had seen

weeks earlier in the studio. The woman was Mrs. Plumer, one of the original owners of the building he worked at. She had donated a large sum of money toward the construction of the hospital. The part that unnerved him most was the fact that she was dead and had been for almost forty years.

On another occasion, an employee arrived at work about 4:30 a.m. He pulled his car into the empty parking lot and exited his vehicle. As he approached the mansion, he noticed a light on in the third-floor tower room. What especially caught his eye was a man standing in the window, shades drawn open, with his hands in his pockets. The man was wearing what looked like an old-fashioned black suit and was staring down at the employee. His face was very ashen, with a dark-colored beard and moustache. The employee thought it odd that someone was in the building so early. Usually he was the first one to work in the morning to open up the building. He opened the door and proceeded up the only flight of stairs that led to the third-floor office area. Once there, he knocked, but no one answered. He opened the door and found the office area dark and void of any life. The shades had been pulled shut. He then searched the entire building and found not one living soul. The employee was unable to explain this due to the fact that if someone had been upstairs they would have had to pass him on the way down the only staircase.

Many weeks later, this same employee was cleaning out a section of the mansion. He came across some old pictures of the Plumer family that had lived in the mansion so many years earlier. To his surprise, one photo looked strangely familiar. It was a picture of Daniel L. Plumer in an old-fashioned suit—the exact same man he had seen in the third-floor tower window.

About a year later, yet another incident occurred. Another employee was working on the second floor of the mansion one afternoon while a secretary was working in her office on the third floor. Suddenly, he heard the secretary screaming and saw her run down the steps. She was hysterical at first, but once she regained her composure she told him that she had seen a young boy dressed in old-time clothing hanging by the neck from a rope that ran down from the ceiling. The employee went to check it out, along with the secretary, who was very hesitant to return upstairs. Upon inspection, nothing was found and nothing was out of place. After that she would only work on the third floor while another employee was working nearby. The secretary quit her job soon after.

Several weeks later, the phantom boy was seen once again by the son of an employee who had brought him to work to help out. While the employee's son was working near the third-floor staircase, he felt the urge to look toward

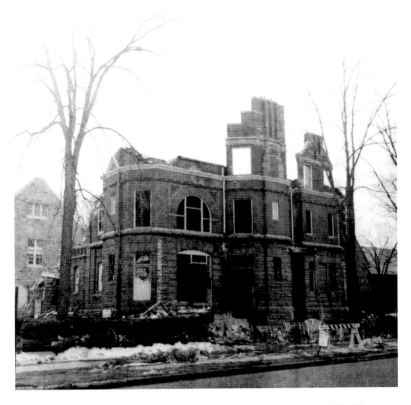

The Plumer mansion as it was being razed in 1972. *Courtesy of Dennis Dalsky.*

the stairs. He glanced toward the stairs and saw a young boy with a rope around his neck hanging from the ceiling over the stairs. He looked away for a moment, and when he looked back the phantom was gone.

So who was the phantom ghost boy? There's no record of a child hanging himself in the mansion, and the Plumers' only son died during infancy. Why did Daniel and Mary Plumer feel the need to stay on after their deaths? We shall never know these answers, so a mystery it shall stay.

HELP FOR THE HAUNTED

We hope that you have enjoyed the stories you have read. We wish to leave you with some information that may be helpful to you or someone you know. Much of what you have just read is the result of investigations that have shown evidence of paranormal activity. About 90 percent of the time when the WPRS investigates, we find non-paranormal explanations for activity that has been reported. An example comes from many years ago, when we were called to the home of a family who was plagued by knocking noises emanating from the second floor of their home. The family members were scared and uneasy living in their own home. After spending a short time there, we concluded that the knocking noise was caused by a coaxial cable slapping the siding of the house when the wind would blow the right way. The family was somewhat embarrassed about this but at the same time much relieved that their home was not haunted.

When the WPRS investigates a site, we start by interviewing the client and researching any history associated with the property. Once that information is collected, we make a determination whether to investigate. Upon arrival at the property, we begin by having the client give us a walk-through of the dwelling. We then ask that the family leave the premises while we investigate. We take baseline EMF, temperature and Geiger counter readings in all areas of the home. We also photograph and draw a rough floor plan of the home. After we establish base readings, we then continue the investigation by conducting EVP sessions and monitoring

areas of interest through the use of digital infrared cameras. Once we collect all of this evidence, we then analyze it and look for anything that cannot be reasonably explained.

If you find that you may be experiencing paranormal activity in your home or place of business, here are some things that you can do prior to contacting a reputable paranormal group. We recommend that you start by keeping a log of any activity you feel is out of the ordinary. Record the time and date so that you may be able to find any patterns. You may want to try taking photos to capture anomalies on film. If you own a video camera, you may want to try to monitor areas with that as well. These are some simple things to try first. If you feel that you need a paranormal group to check out your home or business, there are many reputable groups out there. Of course, you can also contact the WPRS by visiting our website at www.wprs. net. We hope that these tips help you find the answers you seek. Meanwhile, keep an open mind and always look for practical explanations.

BIBLIOGRAPHY

"About the Woodson History Center." Marathon County Historical Society. www.marathoncountyhistory.org/WoodsonHistoryCenter. php?ContentId=65.

"Aytchmonde Woodson, Officer, Marathon Co." www.spoke.com/info/ pFcJ36s/AytchmondeWoodson.

Bellis, J.R. *Bellis' Marathon County Directory including the City of Marshfield for the Years 1891–92.* Wausau, WI: J.R. Bellis, 1891.

City of Rhinelander. www.ci.rhinelander.wi.gov.

Clarke, John C., and E.B. Thayer. *Wausau Histories.* N.p., 1979.

Dennison, Glenn. *Early Beginnings of Wausau.* N.p., 1964.

"The Early History of Wausau and Marathon County Boiled Down to Brief Paragraphs." Editorial. *Wausau Daily Record,* 1879, souvenir ed. State of Wisconsin Collection, University of Wisconsin Digital Collections. digicoll. library.wisc.edu/cgi-bin/WI/WI-idx?type=div&did=WI.WausauDaily. i0019&isize=text&pview=hide.

Elliott, James. *Great Times: The Story of the Wausau Club, 1901–1999*. Wausau, WI: Wausau Club, 1999.

Geisel, Robert K., Robert G. Becker, Phil Carspecken and Margaret Carspecken. *Forever in Focus: Historic Images around the World of Wausau*. Wausau, WI, 2004.

Gibberd, Thomas. "Grand Theater." E-mail to the author, November 9, 2005.

Gillett Area Historical Society—Home. www.gilletthistorical.com.

Green, Shelley. "Wausau Cemeteries." RootsWeb.com Home Page. www.rootsweb.ancestry.com/~wimarath/WausauCemeteries.htm.

Hart, Bill. "People of Marathon County." Marathon County Historical Society. www.marathoncountyhistory.com/People.php.

Hetland, Bill. "A Spirit of Cooperation—Sister Regina Instrumental in Merger." *Wausau Sunday Herald*, August 7, 1988: 1E.

Hettinga, Mary Jane. "Discover Wausau History in Pine Grove Cemetery." *Wausau Daily Herald*, September 20, 2004: B1.

Hettinga, Mary Jane Uecker. *Wausau Chronicles*. Wausau, WI: Birch Lake, 2002.

"History—The Wausau Story." City of Wausau, Wisconsin. www.ci.wausau.wi.us/Home/AboutWausau/HistoryofWausau.aspx.

"History and Legend." City of Mosinee. www.mosinee.wi.us.

"History of Mosinee." Mosinee Area Chamber of Commerce. www.mosineechamber.org/history.php.

"Information." Leigh Yawkey Woodson Art Museum. www.lywam.org.

Janke, John, and Jane Janke Johnson. *Big Bull Falls: Postcard Views of Wausau, Wisconsin*. Vol. II. Wausau, WI: Birch Lake, 2000.

Knol, Ann Schottman. "Movie Theater to Shut Down." *Wausau Daily Herald*, February 2002.

Korbus, Jason. "Theories About Ghosts—Toledo Paranormal & Hauntings." www.examiner.com/paranormal-hauntings-in-toledo/theories-about-ghosts.

Kronenwetter, Michael. *Wisconsin Heartland: The Story of Wausau and Marathon County*. Midland, MI: Pendell Pub., 1984.

Malaguti, Mary L., Maryanne C. Norton and Constant Chilicki. *Final Report, Intensive Historic Survey, City of Wausau, Wisconsin*. Wisconsin, 1984.

Marchetti, Louis. *History of Marathon County, Wisconsin and Representative Citizens*. Chicago: Richmond-Arnold Pub., 1913.

"Milestones, Jan. 15, 1934." *Time*. www.time.com/time/magazine/article/0,9171,746827,00.html.

Mueller, Ottilie. "Wausau's Early Cemeteries." *Rib Mountain Echoes*. Stevens Point, WI: Worzalla Pub., 1967.

Nikolai, Geri. "End of an Era. St. Mary's Hospital Began 65 Years Ago." *Wausau Daily Herald*, May 20, 1970.

Paluch, Amber. "Rogers Reborn as Budget Theater." *Wausau Daily Herald*, February 15, 2001: 3A.

"Poltergeist—Definition." Dictionary and Thesaurus—Merriam-Webster Online. www.merriam-webster.com/dictionary/poltergeist.

Program of Dedication of the New Home of Wausau Lodge 248 Benevolent and Protective Order of Elks. Wausau, WI, 1924.

"Property Records and Maps." Marathon County Register of Deeds. October 2009.

Roll, Todd. "Annie the Ghost of UWMC." The W-Files. www.w-files.com/files/gh_uwmc_annie.html.

———. "The Grand Theater Investigation in Wausau, Wisconsin." In *Real Ghosts, Restless Spirits, and Haunted Places*, by Brad Steiger. Canton, MI: Visible Ink, 2003.

State of Wisconsin Board of Health. Embalmer License, Charles Helke. Madison, Wisconsin. October 30, 1906.

Sugar Camp Wisconsin. www.sugarcampwi.com.

Taylor, Troy. *The Ghost Hunter's Guidebook: The Essential Handbook of Ghost Research*. Alton, IL: Whitechapel Productions, 2001.

"Tuberculosis." Credo Reference. www.credoreference.com/topic/tuberculosis.

Voices from the Past: A Discovery Walk through Pine Grove, St. Michael & St. Joseph Cemeteries. Wausau, WI, 2010.

Wausau Daily Record-Herald. "Festal Scenes Mark Hotel Opening." July 18, 1925: 1.

———. "Helke Funeral Scheduled to Be Held on Friday." August 23, 1937.

———. "'Hollywood' to Open After Remodeling of Fourth St. Building." May 11, 1942: 1.

Wausau Elks Lodge 248. www.wausauelks.com.

Wausau-Merrill Daily Herald. "Old Bus Depot First Building Razed." August 27, 1980.

———. "Wausau…A City to Celebrate!" August 1983.

Wausau Pilot. "Magnificent Elks' Home Dedicated by Impressive Ceremonies Last Evening." September 4, 1924: 1+.

———. "A New Front for the Hotel Bellis." May 12, 1914: 1.

Wisconsin, Wausau. "History of Mayors." City of Wausau, Wisconsin. www. ci.wausau.wi.us/Departments/Mayor/History.aspx.

Wodalski, Ed. "Hotel Wausau—Downtown Landmark Has Served Community Well." *Wausau Sunday Herald*, November 9, 1986: 5C.

Woodson History Center and Yawkey House Museum. *The Yawkey House.* Wausau, WI: Woodson History Center and Yawkey House Museum, n.d.

"Yawkey, Cyrus Carpenter 1862–1943." Dictionary of Wisconsin History. www.wisconsinhistory.org.

ABOUT THE AUTHORS

Shawn Blaschka co-founded the Wausau Paranormal Research Society in 2000 and is the current director. Shawn was born in Wausau and has lived there his whole life. He first became interested in ghosts as a young boy when his dad would share stories about his experiences in the old Plumer mansion, where he worked. Shawn has been studying and investigating the paranormal since childhood and has had several personal encounters with the unknown. Shawn has a degree in criminal science and holds certifications in corrections, fire science and scuba diving.

Anji Spialek has been studying supernatural phenomena for as long as she can remember. She joined the Wausau Paranormal Research Society in 2007 and is currently the assistant director and research specialist. Anji hails from Cincinnati, Ohio, and has called Wausau her home since 2001.

Sharon Abitz was born and raised near Wausau and has been interested in the paranormal since childhood. She is a veteran of the U.S. Army, having served as a Morse code intercept operator in the United States and South Korea. Sharon has an associate's degree in accounting and a bachelor's in sociology and is currently a senior investigator with the Wausau Paranormal Research Society.